D0404093

HEALTH
HAZARDS
MANUAL FOR
ARTISTS

HEALTH HAZARDS MANUAL SIXTH EDITION FOR ARTISTS

MICHAEL MCCANN, PH.D., C.I.H.

ANGELA BABIN, M.S.

The Lyons Press
Guilford, Connecticut
An imprint of The Globe Pequot Press

To buy books in quantity for corporate use
or incentives, call **(800) 962–0973**
or e-mail **premiums@GlobePequot.com**.

Copyright © 2008 by Michael McCann

ALL RIGHTS RESERVED. No part of this book may be reproduced or transmitted in any form by any means, electronic or mechanical, including photocopying and recording, or by any information storage and retrieval system, except as may be expressly permitted in writing from the publisher. Requests for permission should be addressed to The Globe Pequot Press, Attn: Rights and Permissions Department, P.O. Box 480, Guilford, CT 06437.

The Lyons Press is an imprint of The Globe Pequot Press.

Designed by Maggie Peterson

Library of Congress Cataloging-in-Publication Data is available on file.

ISBN 978-1-59921-318-7

Printed in the United States of America

10 9 8 7 6 5 4 3 2 1

CONTENTS

PREFACE TO THE SIXTH EDITION

The *Health Hazards Manual for Artists* has sold about 68,000 copies since its first publication in 1975. The *Health Hazards Manual for Artists* started out as a series of seven articles published in 1974–75 in *Art Workers News*, a publication of the New York based Foundation for the Community of Artists. These articles were compiled into the first edition of the *Health Hazards Manual for Artists*, which was only 32 pages long. In subsequent editions, it was expanded to the present 185 pages.

The sixth edition of the *Health Hazards Manual for Artists* has been updated and several new sections added. The sections on printmaking, ventilation, waste disposal, and respirators have been updated and expanded, and a new chapter on alternative media and modern technology added. And of course, the appendices on Occupational Health Clinics and Safety Supply Sources, and the bibliography, have been updated.

Much of the focus of the changes in the fifth edition of the *Health Hazards Manual for Artists* had been to make it more user-friendly for art students, and still keep it up-to-date for working artists. This was continued in the sixth edition. In addition, Angela Babin is a co-author of this edition. Angela had reviewed the last two editions of the *Health Hazards Manual for Artists*, but is now a formal co-author.

—Michael McCann, PhD, CIH
Angela Babin, M.S.
December, 2007

Part One

HOW ART MATERIALS
AFFECT YOU

One

WHAT IS THE PROBLEM?

Are many art materials hazardous? In 1974, when author Mike McCann first began writing and lecturing about the health hazards of art and craft materials, people found it hard to believe. Convincing people—including artists, school and college officials, and the health professions—that there is a problem was the first and hardest step. The first edition of *Health Hazards Manual for Artists* was a major factor in promoting the awareness of this problem.

The original concern was based on the fact that artists were using many of the same chemicals as industry. And it was known that industrial workers were developing occupational diseases from exposure to these chemicals. The problem was that artists were using these chemicals, often at home, without adequate precautions and usually without even knowing that these chemicals were dangerous. Thus there was concern that artists could develop the same occupational diseases as workers in industry.

And that concern has been shown to be valid. Innumerable case studies have shown that artists can develop dermatitis, lead poisoning, silicosis, liver and kidney damage, nerve damage, reproductive problems, carbon monoxide poisoning, cancer, and similar ailments—all occupational diseases caused by chemical exposure. Industrial hygiene studies involving air sampling have shown, in many instances, that artists can be exposed to hazardous chemicals at concentrations above legal standards.

In 1981 the National Cancer Institute conducted a study of the causes of deaths of artists. This study involved 1,598 artists whose obituaries were published in *Who's Who in American Art* between 1940 and 1969. Death certificates were obtained for 1,253 men and 345 women artists, and their causes of death were compared to the causes of death for all United States men and women. This proportionate mortality study, as it is called, found that male artists had a statistically significant greater number of deaths from heart disease, leukemia, and cancers of the brain, kidney, bladder, colon and rectum. The study also found that the leukemia and bladder cancers were more frequent among painters than sculptors and other artists.

For women artists, the statistically significant increased rates of death were from rectal cancer, breast cancer, and lung cancer. Since there were fewer women than men in the study group, it was harder to find statistically significant results.

This type of epidemiological study does not prove that art materials caused these excess deaths, but simply says there is a statistical relationship between being an artist and developing these diseases. However, workers in industry using the same chemicals that artists use also have excess rates of these same types of cancers.

Now that it has been more generally accepted that art materials can cause occupational diseases among artists, the problem becomes what can be done about it.

The problem of art hazards has several aspects to it, including the presence of extremely toxic chemicals in many art materials, inadequate labeling of art materials, the lack of adequate training of students about art hazards in the schools, and improper diagnosis of illnesses caused by exposure to toxic art materials.

Many art materials still contain very hazardous chemicals that are often unnecessary because adequate substitutes are available. The classic example is flake white in oil paints. A few painters say it is a necessary pigment but most painters have long ago replaced it with zinc white or titanium white. Other examples of chemicals that should be eliminated include cadmium in low melting silver solders for jewelry, asbestos in talcs and clays or as insulation, and lead compounds (including lead frits), radioactive uranium oxide in pottery glazes, and turpentine as a paint solvent. Cadmium fumes,

asbestos, and uranium oxide all have been shown to cause lung cancer, and lead compounds are well known as a cause of nerve damage, kidney damage, and reproductive system damage. Turpentine can cause kidney damage, allergies, and is absorbed through the skin.

Some progress has been made in the area of safer substitutes. The Nuclear Regulatory Commission banned uranium compounds in enamels in 1984. In the 1980s, several art material manufacturers came out with lines of lead-free pottery glazes and enamels. Asbestos is still a major problem in talcs and clays, but some companies are experimenting with talc-free clays and there are some asbestos-free talcs available. Benzene, which can cause leukemia, was eliminated from art materials such as paint strippers in 1978. Turpentine can be replaced by odorless mineral spirits in most cases.

There has been a lot of progress in the area of the labeling of art materials. The problem was that, prior to 1988, the Federal Hazardous Substances Act only required labeling of chemicals that are immediately or acutely toxic. Warnings about the long-term or chronic hazards of art materials had not been mandatory and almost no manufacturer listed chronic hazards. As the result of congressional and various state legislative hearings on art hazards, the question of chronic hazard labeling became a major concern during the 1980s.

In the early 1980s, a voluntary labeling standard (ASTM D-4236) requiring warning labels about chronic hazards of art materials was developed under the auspices of the American Society for Testing and Materials (ASTM). This voluntary standard was developed by representatives from industry, artists' organizations, toxicologists and other interested parties, including one of the authors of this book.

Starting in 1985, art materials with chronic hazard labeling certified by the Arts and Crafts Materials Institute (ACMI), an industry trade association that originally dealt with children's art materials (see Chapter 21 on Children's Art Materials), began to appear on the market. The ACMI CL seal is found on art materials for adults that are certified to be properly labeled for any known health risks and is accompanied by information on the safe and proper use of such materials.

The problem with the voluntary standard approach is that it allowed each manufacturer to decide whether it wanted to put a chronic hazard

warning label on its products. Many of the larger manufacturers of fine art materials did so, but most crafts manufacturers and small manufacturers did not put chronic hazard warning labels on their art materials.

We favored the mandatory labeling of the chronic hazards of art materials, as did many others. It should not be up to the manufacturer to decide whether it wants to put warning labels on its products. During the mid 1980s, laws requiring chronic hazard labeling of art and craft materials and banning toxic chemicals in children's art materials were passed in California, Florida, Illinois, Oregon, Tennessee, and Virginia.

At the same time, lobbying went on in Washington by many artists' organizations and the U.S. Public Interest Research Group in support of a national labeling law. This was even supported by many manufacturers and their trade associations since they did not like different labeling requirements in different states, nor the fact that companies not putting warning labels on their products had a competitive advantage. As a result, in 1988 Congress passed the Labeling of Hazardous Art Materials Act. This law amended the Federal Hazardous Substances Act to make ASTM D-4236 into law, and required the Consumer Product Safety Commission to define what is a chronic hazard. The law also allowed the Consumer Product Safety Commission to obtain court injunctions against any school that purchased chronically toxic art supplies for use in elementary school.

One of the major problem areas is the schools where art is taught. We have found hazardous art materials being used without suitable precautions at every level from preschool through elementary and secondary schools to colleges. A reason for this is that many teachers still do not know about the hazards of art materials they use or how to work safely. In addition, school administrators often do not pay attention to teachers' requests for proper ventilation or proper protective equipment. This has resulted in lawsuits by injured students against both teachers and schools.

This is not to say that all teachers and schools are not addressing the problem of art hazards. Many art schools, school districts, and teachers' organizations have had speakers from the Center for Safety in the Arts to educate them about art hazards. In addition, the Center for Safety in the Arts performed many inspections of art schools and school districts at their request to ascertain hazards and make recommendations for their correction.

Further the National Association of Schools of Art and Design (NASAD) in the mid-1980s included safety as an essential part of certifications or recertifications of college art programs.

Teaching about the hazards of art materials and how to work safely should occur when students first learn art techniques. If included in the art and art-education curriculums in our schools, this would ensure that the next generation of artists knows about the hazards of their materials and how to work safely with them.

The present generation of artists, however, also needs to be informed about art hazards. We tried to accomplish this by giving lectures and workshops for artists' organizations and by publishing a large amount of information on art hazards. In addition, the Art Hazards Information Center, a project of the Center for Safety in the Arts, answered about fifty written and telephone inquiries daily on art hazards. Unfortunately, this service stopped when the Center for Safety in the Arts closed in 1995 due to lack of funding.

Artists do get ill from overexposure to hazardous art materials and it is essential that they can obtain a proper diagnosis of their illness. Unfortunately, most physicians do not have any training in the toxic effects of chemicals and cannot properly diagnose such an illness. In fact, we have seen instances where illnesses diagnosed as psychosomatic have been identified as lead poisoning once the artist went to a physician with training in occupational medicine. If in doubt, you should not hesitate to go to a physician with the needed expertise. Today, there are dozens of occupational health clinics around the country with expertise in the toxic effects of chemicals found in art materials. (See Appendix 1.)

Two

RISK FACTORS

Just how hazardous to health are art materials? The actual risk involved depends on several factors, most importantly length, frequency, and amount of exposure, the toxicity of the material, total body burden, effects of exposure to multiple chemicals, and personal susceptibility. In addition, of course, a chemical has to contact or enter the body to cause injury.

CONDITIONS OF EXPOSURE

How much material you are exposed to, for how long, and how often, are crucial factors determining the total potential exposure to a chemical.

For example, an artist who is exposed only to a cup of a toxic solvent for a few minutes a day is much less likely to develop problems than an artist who might use several pints of the same solvent over a period of some hours. Similarly, exposure to toxic materials once a week or month is much less hazardous than daily exposure.

In some instances, an artist working long hours preparing for a show or at the end of the school term could have greater exposure than a worker in industry using the same chemical eight hours a day. For example, the Threshold Limit Values (TLVs) used in industry to determine supposed safe levels of exposure to a chemical are based on an eight-hour work day. This means that there are eight hours of exposure to the chemical, and then the body has

sixteen hours without exposure to detoxify and excrete the chemical. If, however, you are working twelve or more hours a day, then you have twelve hours of exposure to the chemical instead of eight hours, and your body has only twelve hours instead of sixteen hours to get rid of the chemical.

TOXICITY

The toxicity of a chemical is defined as its ability to cause damage to the human body. The more toxic the chemical, the less it takes to injure you. For example, small amounts of lead white pigment can cause poisoning if ingested, whereas the body can tolerate much larger amounts of iron oxide pigments without ill effects. Lead therefore has a higher toxicity than iron. Whenever possible, you should choose the least toxic art material in order to minimize the chances of injury.

TOTAL BODY BURDEN

The total body burden of a chemical is the total amount of that chemical in the body from all possible sources. For example, if you are doing stained glass, you might get a body burden of lead from exposure to lead fumes from the solder, lead dust from the came, and possibly lead pigments.

However, one can also have exposure to lead from non-working sources, for example, from the environment or home, that contribute to the total body burden. These include lead from drinking water that comes through lead pipes, from renovation on lead-containing wall paint, from any nearby smelters, and from lead in food or drinks that resulted from the dissolving of lead from pottery glazes on cups and other food and drink containers. All of these sources can contribute to the total amount of lead in your body—the total body burden.

MULTIPLE EXPOSURES TO CHEMICALS

Exposure to many different chemicals can also increase the risk and extent of injury to a particular organ. For example, damage to the lungs resulting from excess exposure to carbon arc gases, solvent vapors, cigarette smoke, air pollution, and the like. In some cases, this effect is not a simple additive effect but can be a multiplicative or synergistic effect. An example is smoking and asbestos exposure. Smokers have a tenfold increased risk of lung

cancer compared to nonsmokers. Nonsmokers who work with asbestos have about a fivefold excess risk of lung cancer. Smokers who work with asbestos, however, can have about a fifty- to ninety-fold excess risk of lung cancer.

Similarly, exposure to many chlorinated solvents (e.g. carbon tetrachloride or trichloroethylene) and alcoholic beverages can have a serious and possibly even fatal synergistic effect.

The major problem is that it is impossible to test all the combinations of chemicals to which we are exposed to determine these possible synergistic effects. This becomes an important reason to minimize exposure to all chemicals to the greatest extent possible.

PERSONAL SUSCEPTIBILITY

If two people are in the same studio and have the same exposure to toxic chemicals, one might get ill and the other might not. Why? The reason is the individual susceptibility of people and the existence of high-risk groups.

One of the highest-risk groups is children because of their low body weight and several other reasons. The problems of children and art materials will be discussed further in chapter 21. Other high-risk groups include smokers, heavy drinkers, asthmatics, people with chronic heart, liver, or lung disease or other problems, pregnant women, and the elderly.

People with a variety of disabilities are also at higher risk. For example, solvents could induce epileptic seizures in susceptible people, and noise in woodshops could further damage the residual hearing of people with hearing impairments.

ROUTES OF ENTRY INTO THE BODY

There are three common ways in which toxic substances can enter the body: (1) by skin contact, (2) through inhalation, and (3) through ingestion.

Skin contact is the most frequent way in which materials enter the body. Our skin has a defensive barrier consisting of an outer waxy coating and a layer of dead cells intertwined with a tough protein called keratin. Normally this barrier protects the skin against chemicals and physical injury. However, many substances—acids, caustic alkalis, organic solvents, peroxides, and bleaches—can readily destroy this protective coating and attack the skin layers underneath, causing various types of skin ailments.

Some chemicals—phenol (carbolic acid), turpentine, benzene, toluene, and methyl alcohol, for example—can even penetrate farther and enter the bloodstream to travel to other parts of the body. By stripping away the protective waxy skin coating, many organic solvents make it possible for other chemicals to penetrate the skin's barrier. In addition, many chemicals may be absorbed through contact with the eyes. Obviously, the way to prevent these hazardous substances from entering the body through the skin or eyes is to ensure that the chemicals don't contact the skin or eyes.

The second most common way for substances to enter the body is through breathing in their vapors, spray mists, gases, fumes, smoke, and dusts. Some substances—for example, glacial acetic acid (a "stop bath" in photography), sulfur dioxide gas from kilns, welding fumes, and noxious gases resulting from overheating of many plastics—can immediately damage the sensitive linings of the airways and lungs. Others, especially dusts, can cause chronic diseases. One of the important factors here is the size of the particles. Finer particles enter deeper into the lungs. Large particles can get trapped by the mucus of the nose and upper respiratory passages, where they can be swallowed or spit up. The shape of the substance is also relevant. Thin needle-shaped asbestos fibers can actually stick into the lung.

Whether or not a substance gets beyond the lungs to affect the rest of the body depends on how soluble it is in the blood.

The third method of exposure is through ingestion. This occurs more often than many people realize through mouth contact with contaminated hands, food, and cigarettes. This can especially be a problem for artists whose studios are in their living quarters. The habit of pointing paintbrushes with the lips can be particularly dangerous. Another source of ingestion is inhaled dusts that are carried up into the throat by lung-clearance mechanisms, and then swallowed. Once in the stomach, the body's defenses act to absorb the harmful materials into the bloodstream slowly, and in small amounts. However, this is often not sufficient to prevent poisoning.

Three

EFFECTS OF ART MATERIALS ON THE BODY

Now that we have seen how dangerous art materials enter the body, let us look at how the materials can damage the body. One of the first things we have to know is the difference between acute and chronic illness. An acute illness is one that occurs as a result of a single, often large, exposure and that occurs within a short period after the exposure. Examples are burns from exposure to concentrated acids and chemical pneumonia from overexposure to cadmium fumes from silver soldering. A chronic illness is one that occurs after exposure over a period of months, years, or even decades, often from low levels of exposure. Chronic illnesses can occur in two ways: from buildup of a chemical in the body, as in chronic lead poisoning; or from an accumulation of damage to the body from repeated exposures to the chemical. In the latter case, the chemical does not accumulate in the body; only the damage it does builds up. Examples of the latter are nerve damage from exposure to certain solvents, cancer, and chronic bronchitis.

THE SKIN

As mentioned earlier, many materials can harm the skin directly. In fact, skin ailments are the most frequent kind of occupational hazard caused by

chemical substances. Most artists whom we have talked to have had at some time or another a rash, burn, or other skin problem caused by working with art materials.

Skin diseases caused by chemicals are mostly of two types: direct irritation and allergies.

Chemicals that cause direct irritation (irritant dermatitis) are called irritants, and affect everyone who comes in sufficient contact with them. The types of damage that can appear include reddening, itching, blistering, thickening, hardening, and flaking of the skin. In some cases, it takes a long time and repeated exposure to show damage. The condition lasts as long as exposure continues and usually disappears some time after contact is ended. Irritants commonly encountered by artists include acids, alkalis, organic solvents (xylene, toluene, and other aromatic solvents, chlorinated hydrocarbons, turpentine, petroleum solvents, ketones) and such others as chromium compounds, arsenic compounds, and fiberglass.

Besides irritants that affect everybody, many substances are sensitizers and cause allergies. While most sensitizers affect only a few people, some are so strong they will affect large numbers of people. Allergies don't occur at the first exposure. Often a person can work with a material for years before developing a sensitivity to it. After that, however, the sensitivity never disappears and even very small amounts of the material can bring on the allergic reaction.

Some common sensitizers that affect many people include many plastics materials (in particular, epoxy resins and amine hardeners), chromate and bichromate salts, nickel and cobalt compounds, formaldehyde, turpentine, and many tropical woods.

Skin cancer is another type of skin disease that is of concern. The major problem is that we don't know whether many common chemicals cause cancer or not because cancers usually take twenty to forty years to develop. Some substances—including arsenic compounds and lampblack—have been definitely shown to cause skin cancer. The major cause of skin cancer, however, is ultraviolet light. This is why people who work outdoors or who spend lots of time in the sun have high rates of skin cancer. Sources of ultraviolet radiation to which artists can be exposed include carbon arcs and arc welding and working in outdoor studios.

The eyes are even more sensitive than the skin to damage. Examples of eye problems are damage to the cornea from ultraviolet radiation, cataracts from infrared radiation, and conjunctivitis and other eye diseases from exposure to acids, ammonia and other alkalis, peroxide hardeners, and other irritants.

RESPIRATORY SYSTEM

Acute respiratory diseases result when strongly irritating airborne substances (such as ammonia, nitric acid etching gases, glacial acetic acid, ozone from welding) burn the tissues of the lungs or upper respiratory system. If the chemical dissolves in the fluids in the upper respiratory system, then acute bronchitis can result. Examples include overexposure to sulfur dioxide from kilns and to glacial acetic acid. If the chemical reaches the air sacs at the bottom of the lungs, then possibly fatal chemical pneumonia (pulmonary edema) can result. This can occur from overexposure to nitrogen dioxide from acid etching, ozone from arc welding, and cadmium fumes from silver soldering. In addition, hypersensitivity pneumonia is often an acute disease caused by exposure to redwood dust, ivory dust, mother-of-pearl, moldy cotton, and some feathers. Metal fume fever, a flu-like disease, can result from overexposure to zinc and copper fumes, in particular, from welding and foundry operations.

Chronic lung diseases, such as chronic bronchitis and emphysema, can result from repeated exposures over several years to low levels of airborne irritating substances. This results in damage to the larger airways that lead to the air sacs. Over the years, these chronic diseases can be progressive and result in more and more coughing and mucus production and an increased susceptibility to respiratory infections. Smoking is the major cause of these diseases, but they can also be caused by exposure to many other irritants including nitrogen dioxide, ozone, sulfur dioxide, acid soldering fluxes, and others.

Another major form of lung disease is pulmonary fibrosis (e.g. silicosis), a permanent scarring of the lung tissue. This can result from continual exposure to certain dusts, such as asbestos, silica from clays and many stones, beryllium, and redwood sawdust. This disease is similar to miners' black lung.

Many materials including western red cedar and many tropical woods, formaldehyde, fiber-reactive (cold water) dyes, isocyanates (found in polyurethane resins), epoxy hardeners, turpentine, nickel compounds, and rosin core solder fumes can cause asthma or other respiratory allergies.

Respiratory cancer can be caused by exposure to lead and zinc chromate (chrome yellow and zinc yellow), asbestos, arsenic, cadmium, nickel, uranium oxide, and of course smoking. Hardwood dust may cause nasal and nasal sinus cancer; formaldehyde causes nasal cancer in animals.

HEART AND CIRCULATORY SYSTEM

If the lungs are severely damaged, this puts an enormous strain on the heart as it then has to pump more blood to try to get enough oxygen for the body. In fact, heart failure is a major cause of death for people with chronic bronchitis, emphysema, and pulmonary fibrosis.

However, the heart is also directly susceptible to many chemicals. Barium compounds, cobalt compounds, and several solvents—for example, methylene chloride, methyl chloroform, freons, and toluene—can cause heart damage, the latter by inducing changes in heart rhythms (arrhythmias) at high levels.

The circulatory system is also susceptible to damage from chemicals that interfere with the transport of oxygen through the blood. The actual oxygen-carrying molecule in red blood cells is hemoglobin. Chemicals like carbon monoxide, methylene chloride, and some photographic developers, like aminophenol, can affect the hemoglobin so that it can no longer carry oxygen, leading to oxygen starvation and possibly death.

Chemicals that affect the formation of red and white blood cells and platelets can cause very serious illness. Benzene (benzol), for example, destroys the bone marrow so it no longer produces these cells. This results in aplastic anemia and possibly leukemia. Other substances that can cause anemia include lead, cadmium, and many glycol ethers.

LIVER

One of the liver's main functions is to detoxify substances, both those that enter the body from outside and those that the body produces. However, it

has a limited capacity to do this and liver damage can result when this capacity is exceeded. Further, when the liver is damaged it can't detoxify the body's own toxins, which leads to more damage.

One common symptom of liver damage is jaundice, a yellowish or greenish coloring of the skin. Other symptoms of liver damage tend to be vague and can include tenderness or swelling of the liver, nausea, and loss of appetite. One type of liver disease is hepatitis or inflammation of the liver. Hepatitis is known as a viral disease, but it can also be caused by chemical substances. Hepatitis will usually heal without lasting damage except in severe cases. Then scarring of the liver (cirrhosis of the liver) can result. Some typical substances that can cause liver damage are metals like lead and arsenic, polychlorinated biphenyls (PCBs), and many solvents, including toluene, xylene, ethyl alcohol, and especially chlorinated solvents such as carbon tetrachloride and perchloroethylene.

KIDNEYS

Kidney damage can result from exposure to such substances as lead, arsenic, cadmium, mercury, selenium, uranium, chlorinated hydrocarbons, and turpentine. Bladder cancer may result from exposure to benzidine-derived direct dyes (used for dyeing cotton and silk). Silk-kimono painters in Japan, for example, who used these dyes have a high rate of bladder cancer. In 1996, the Environmental Protection Agency (EPA) required notification of the EPA before benzidine dyes could be manufactured, imported or distributed in the United States.

NERVOUS SYSTEM

The nervous system is very susceptible to damage, and except for the peripheral nerves, damage is permanent. In particular, the brain can only survive for a few minutes without oxygen, and chemicals that interfere with the oxygen supply can cause brain damage. The brain can also be poisoned by chemical substances like carbon disulfide, hydrogen sulfide, and hydrogen cyanide. Heavy metals like lead, mercury, and arsenic can cause nerve-function disorders and even death.

Many substances have a narcotic effect and cause depression of the central nervous system. Symptoms include intoxication, loss of coordination,

dizziness, headaches, nausea, and in severe exposures, blackout and even death. We have seen several instances of artists being in car accidents or being arrested for drunken driving after working with organic solvents that are strong central nervous system depressants. Examples of these are alcohols, chlorinated hydrocarbons, toluene, xylene, and ketones.

Evidence has accumulated since the late 1970s that chronic exposure to high concentrations of many solvents can cause irreversible brain damage, called chronic toxic encephalopathy. Symptoms include memory loss, emotional swings, confusion, problems with hand-eye coordination, lowered IQ, and other psychoneurological changes. Solvents that appear to be associated with this brain damage include the chlorinated hydrocarbons, mineral spirits, and aromatic hydrocarbons (see the Solvents section in the next chapter).

Some chemicals can damage the peripheral nervous system (hands, arms, feet, and legs). Examples include lead, arsenic, mercury, methyl butyl ketone (found in some lacquer thinners) and n-hexane (found in low-boiling naphthas, some spray adhesives, and some rubber cements and their thinners). In severe cases, there may also be permanent central nervous system damage.

THE REPRODUCTIVE SYSTEM

We can divide the effect of chemicals on the reproductive system into three basic categories: effects prior to pregnancy, effects during pregnancy, and effects on the newborn infant and child.

Prior to pregnancy, some chemicals (including those used in art) may affect both men and women. Reactions include interference with sexual function (e.g., loss of sex drive), lowered fertility, genetic damage, and difficulty in conceiving. Women can develop menstrual disorders, and men can develop problems with the testes and prostate.

Lead, for example, causes menstrual disorders in women, and loss of sex drive, atrophy of the testes, and possible sperm alteration in men. It is also thought to cause decreased fertility and mutations. Glycol ethers may cause sterility in men and testicular atrophy. Carbon disulfide, a solvent, also severely affects the reproductive systems of both men and women. Cadmium and manganese may affect the male reproductive system. Toluene and xylene can cause menstrual problems.

Some epidemiological studies have shown that the wives of chemical workers have higher rates of miscarriages and stillbirths. Animal studies have similarly shown that the offspring of animals exposed to many chemicals have higher rates of miscarriages, stillbirths, birth defects, etc.

Prior to pregnancy, exposures to the man are probably more critical than exposures to the woman. The reason for this is that women have all their eggs from birth, and once a month an egg goes through a short developmental period, whereas men are constantly producing sperm. Since it takes about three months for sperm to fully mature, there is an extended period for men prior to pregnancy when sperm can be damaged, possibly resulting in harm to the future fetus. Some chemicals, called mutagens, might cause mutations in the sperm that might cause birth defects that can be inherited and passed from generation to generation. Unfortunately, very few studies have been done in this area.

Chemicals causing damage during pregnancy can affect either the pregnant woman or the developing fetus. In the first case, the effect is due to the fact that during pregnancy a woman's metabolism is very different from normal. The amount of blood volume increases 30 to 40 percent without increasing the amount of iron. This can make a pregnant woman more susceptible to chemicals like lead and benzene, which can cause anemia. In addition, pregnant women are susceptible to respiratory problems and certain types of physical strain.

Many chemicals—called teratogens—can damage the growing fetus, even when present in very small amounts, and cause severe birth defects. Thalidomide is a classic example. Other chemicals are fetotoxic and may cause spontaneous abortions and miscarriages. Examples of chemicals that are teratogenic or fetotoxic include many metals (for example, lead and cadmium); many organic solvents (benzene, toluene, xylene, glycol ethers, chlorinated hydrocarbons, carbon disulfide); carbon monoxide (cigarette smoking causes underweight babies); anesthetic gases, aspirin, and many others. In addition, some chemicals may cause cancer in the children of women exposed to them during pregnancy. Examples are some pesticides and diethylstilbestrol (DES).

Finally, many chemicals can injure infants and children. One example is poisoning of an infant caused by breastfeeding when the mother has been

exposed to toxic chemicals. For example, methylene chloride has been shown to be present in the mother's milk up to seventeen hours after exposure. Other problems include exposure caused by children being present when toxic substances are being used, and the carrying home of toxic dusts on clothes and shoes. In one instance, an eighteen-month-old girl got lead poisoning because she played in the area where her parents were doing stained glass.

One major problem is that most chemicals—including most art materials—have not been tested to see if they cause mutations or other types of damage to sperm or eggs before pregnancy, or if they damage the fetus during pregnancy. It is becoming evident that many chemicals might do so.

The best advice we can give prospective parents is similar to the advice doctors give pregnant women about medications. They suggest avoiding medications if possible, not because we don't know if they are dangerous, but because we don't know if they are safe. Therefore, a prospective male parent should avoid exposure to toxic chemicals for the three months prior to an intended pregnancy, and a pregnant woman should avoid exposure during the entire pregnancy.

Note that we do not mean avoiding toxic chemicals. We mean don't use them if they will get into the body. If the only hazard is skin absorption or accidental ingestion—for example, painting with acrylics or watercolors—then careful work habits such as wearing gloves and not eating while you work can ensure that the chemicals do not get into the body. We recommend against oil painting with solvents at these times because it is too difficult to completely avoid inhalation of the solvent vapors. Of course, if you have adequate local exhaust ventilation for a process that eliminates inhalation problems, then solvents and other toxic airborne chemicals can also be used. For art students who cannot control what other students are using, special arrangements such as separate work areas or avoiding certain classes might be necessary.

Obviously, this approach doesn't work for unplanned pregnancies, both since the male parent doesn't know to take extra precautions beforehand, and the female parent usually doesn't know she is pregnant for at least several weeks, and the first twelve weeks of pregnancy are the most risky. This makes it crucial to minimize exposure to toxic chemicals at all times.

Four

SOLVENTS AND AEROSOL SPRAYS

Solvents are one of the most underrated art hazards. They are used for a million purposes: to dissolve and mix with oils, resins, varnishes, and inks; to remove paint, varnish, and lacquers; to clean brushes, tools, silk screens, and unfortunately even hands. As a result, artists are continually being exposed to solvents.

Almost all organic solvents are poisonous if swallowed or inhaled in sufficient quantity, and most cause dermatitis after sufficient skin contact. High concentrations of most solvents can cause narcosis (dizziness, nausea, fatigue, loss of coordination, coma, and the like). This can increase the chances for mistakes and accidents. As mentioned earlier, long-term exposure to high concentrations of many solvents may cause brain damage. In particular, aromatic hydrocarbons, aliphatic hydrocarbons, and chlorinated hydrocarbons appear to be implicated. Some solvents—for example, benzene (benzol) and carbon tetrachloride—are so toxic that they shouldn't be used. Other solvents—for example, acetone and ethanol (ethyl or grain alcohol)—are reasonably safe.

Solvents fall into several classes with similar properties. If one member of a class of solvents is toxic, usually a different safer solvent from that class can be chosen.

Alcohols are generally anesthetics and irritants of the eyes and upper respiratory tract. In high concentrations, methanol (wood or methyl alcohol) can cause dizziness, intoxication, blurred vision, and possible liver and kidney damage. If swallowed, it can cause blindness and even death. Ethanol, available as denatured alcohol containing some methanol, is a safer solvent. Amyl alcohol acts on the nervous system, causing dizziness, nausea, vomiting, and double vision.

Aliphatic hydrocarbons, also called petroleum distillates, tend to be less toxic than most other solvents. They have a mild narcotic effect and, in large amounts, can cause lung irritation. If ingested, they may cause pulmonary edema (chemical pneumonia) and possible death due to aspiration into the lungs. Petroleum distillates are also skin irritants. n-Hexane, one of the most volatile petroleum distillates, may cause peripheral neuropathy—nerve damage and possible paralysis of arms and legs—from chronic inhalation of large amounts. These symptoms will usually disappear after a couple of years, but sometimes, with very high exposures, permanent damage to the central nervous system can result. Hexane is found in some "extremely flammable" rubber cements and their thinners, in some aerosol spray adhesives and other aerosol spray products, and in low-boiling naphtha. In the last couple of decades, hexane has been replaced by the less toxic heptane in many products. Other petroleum distillates, in increasing order of boiling point, are gasoline, benzine (VM&P Naphtha), mineral spirits (including odorless paint thinner, odorless mineral spirits, turpentine substitutes, white spirits), and kerosene. Normal mineral spirits has about 15–20% aromatic hydrocarbons. Odorless mineral spirits (odorless paint thinner) and turpenoid have these more toxic aromatic hydrocarbons removed, and are recommended as substitutes for regular mineral spirits and turpentine. Uses: paint thinners, rubber cement thinners, silk screen poster inks, cleanup solvent and similar products.

Aromatic hydrocarbons are among the most dangerous solvents. They may be absorbed through the skin, although their major hazard is by inhalation. In general they are strong narcotics. The most dangerous is benzene (benzol), which causes chronic poisoning from the cumulative effect of exposure to small amounts. Its effects are destruction of bone marrow, leading to

a loss of red and white blood cells, and sometimes leukemia. Toluene (toluol) doesn't have the long-term chronic effects of benzene on the bone marrow, but may cause liver and kidney damage. Its immediate effects can be more severe than those of benzene if a person is exposed to a high enough concentration. Toluene may also cause adverse reproductive effects. With proper ventilation, however, toluene is a suggested replacement for benzene. Xylene (xylol) is similar to toluene. Styrene is more toxic than toluene or xylene and may cause respiratory irritation, narcosis, and liver, kidney, and possibly nerve damage. Uses: resin solvent, paint and varnish remover, fluorescent dye solvent, common silk screen wash-up, lacquer thinners, aerosol spray cans, and others.

Chlorinated hydrocarbons, like aromatic hydrocarbons, are very hazardous. Some have been used as anesthetics in the past, but were found to be too toxic. All of them dissolve the fatty layer of the skin and can cause dermatitis. They also cause liver and kidney damage. Drinking alcohol after exposure to many chlorinated hydrocarbons can make people very sick and may be fatal. One of the most toxic chlorinated hydrocarbons is carbon tetrachloride and it shouldn't be used. It can be absorbed through the skin and exposure to small amounts can cause severe liver and kidney damage. Exposure to larger amounts can cause unconsciousness and death, especially if alcoholic beverages are ingested. Other toxic chlorinated hydrocarbons include tetrachloroethane (acetylene tetrachloride), chloroform, ethylene dichloride, perchlorethylene and trichloroethylene. The last four solvents have been shown to cause liver cancer in mice. Methyl chloroform (1, 1, 1-trichloroethane) appears to be less toxic than other chlorinated hydrocarbons at low concentrations, but has caused many fatalities when inhaled at high concentrations (for example, "glue sniffing" or working in enclosed spaces). Methylene chloride (dichloromethane) is highly volatile and high concentrations may cause narcosis, lung irritation, pulmonary edema, and is a probable human carcinogen. Methylene chloride also decomposes in the body to form carbon monoxide and inhalation of large amounts has resulted in fatal heart attacks. People with heart problems and smokers are particularly at high risk. Although most of the chlorinated hydrocarbons are not flammable, they may decompose in the presence of ultraviolet light or excess heat (e.g., a lit cigarette) to form the poison gas phosgene. In general,

try to replace chlorinated hydrocarbons with less toxic solvents. Uses: wax, oil, resin, grease and plastics solvent, paint strippers.

Esters are eye, nose and throat irritants and have anesthetic effects. Most common acetates are not skin irritants or sensitizers. Ethyl acetate is the least toxic, followed by methyl and amyl acetates. They have good odor-warning properties. Uses: lacquer, resin, and plastics solvent.

Glycol ethers and their acetates have been found to be much more toxic than previously thought. Methyl cellosolve (ethylene glycol monomethyl ether) and butyl cellosolve (ethylene glycol monobutyl ether) are known to cause anemia and kidney damage. Cellosolve (ethylene glycol monoethyl ether) and its acetate were considered less toxic. Animal and human studies, however, show that cellosolve, methyl cellosolve and their acetates can cause birth defects, miscarriages, testicular atrophy, and sterility at low levels. All glycol ethers need study to determine if they also cause adverse reproductive effects. Uses: photoresists, color photography, lacquer thinner, paints, aerosol sprays.

Ketones cause narcosis and irritation to the eyes and upper respiratory tract in high concentrations. Their odor-warning properties are a good indication of the degree of exposure. They also cause defatting of the skin upon prolonged exposure, resulting in dry, scaly, cracked skin. Acetone is one of the safest solvents (except for its high flammability) and does not seem to have any lasting effects. Methyl ethyl ketone (MEK) is more toxic than acetone. Methyl butyl ketone may cause peripheral neuropathy similar to that caused by n-hexane. Methyl ethyl ketone acts synergistically with both n-hexane and methyl butyl ketone to cause neuropathy at levels that neither would by itself. Other highly toxic ketones include cyclohexanone and isophorone. Uses: solvents for lacquers, oils, waxes, plastics, vinyl silk screen inks, and so forth.

OTHER SOLVENTS

Turpentine is a common oil paint and varnish thinner. Turpentines from many sources are skin irritants and sensitizers for many people, and can be absorbed through the skin. Their vapors are irritating to the eyes, nose, and throat upon prolonged exposure, and some turpentines may cause severe kidney damage. Resulting symptoms include headaches, gastritis, anxiety,

and mental confusion. Turpentine is highly poisonous by ingestion; one tablespoon may be fatal to a child. Odorless mineral spirits is a recommended substitute.

Citrus solvents (d-limonene) have been touted as non-toxic. They are definitely less hazardous by ingestion than most other solvents, although they often have a citrus-like odor that has caused children to drink them when they have been carelessly left around. They can still make a child sick, but are less likely to cause fatalities. There have been some reports of skin, eye and respiratory irritation from their use. In addition, d-limonene oxidizes when exposed to the air. This oxidized form is a strong sensitizer and can cause allergic reactions.

AEROSOL SPRAYS

Artists are using a multitude of aerosol sprays today: fixatives, retouching sprays, paint sprays, varnishes, adhesive sprays, and the like. Aerosol sprays are very dangerous unless used so that neither the user nor someone nearby breathes the vapors. The fine mists containing possible toxic substances, such as paints, varnish, and adhesives, can remain in the air for hours before settling. Further, they penetrate deep into the lungs. Beside the dangers from the substances dissolved in the sprays, the solvents and propellants are often a hazard. Also many spray product formulations contain several solvents that may not have been researched for the hazard of their combined effect.

For example, many sprays contain toluol and chlorinated hydrocarbons. In spray form, these solvents may be more dangerous than in vapor form because the mists contain large quantities of solvents. Concern about propellants mounted when it was disclosed in the 1970s that many spray products contained vinyl chloride, a chemical that has been shown to cause liver cancer. These products have been withdrawn from the market. Many propellants and solvents used in aerosol cans are also highly flammable.

Air brushes and spray guns are also highly hazardous since they produce fine mists that can enter the lungs.

ACIDS AND ALKALIS

Concentrated acids are very corrosive to the skin, eyes, respiratory system, and gastrointestinal system. Dilute acids can cause skin irritation upon repeated or prolonged contact. If acid is spilled on your skin, wash with lots of water. In case of eye contact, rinse your eyes with water for at least fifteen minutes and contact a physician. An important safety rule when mixing acids is to add the acid to the water, not the other way around. Strong acids include glacial acetic, carbolic (phenol), chromic, hydrochloric, nitric, sulfuric, hydrofluoric, and perchloric acids. Chromic acid is also a skin sensitizer. The nitrogen oxide gases produced from etching metals with nitric acid are very dangerous since they burn the lungs and may result in pulmonary edema (fluid in the lungs). Uses: cleaning metals, etching metals, dyeing assistants, photochemicals, glass etching, and the like.

Concentrated alkalis can cause severe burning of the skin, eyes, and respiratory and gastrointestinal systems from a single exposure, while dilute alkalis can cause skin irritation from repeated or prolonged exposure. Eyes are particularly susceptible. Potassium hydroxide (caustic potash) and sodium hydroxide (caustic soda) are the most dangerous; other alkalis that cause burns are sodium carbonate, potassium carbonate, calcium

oxide (quicklime or unslaked lime), sodium metasilicate, sodium silicate, and ammonia. Ammonia vapors and quicklime dust can also damage the lungs. Uses: dyeing assistants, ceramics, photochemicals, paint removers, and similar materials.

Six

METALS AND MINERALS

Metals and minerals are used in a wide variety of art processes, including painting, printmaking, ceramics, sculpture, metalworking, and more. They have been used for centuries, and artists have been developing illnesses from their use for centuries.

A crucial factor in the ability of metal and mineral dusts to cause illness by inhalation is their particle size. Particles smaller than 5 microns (about 1/5000 of an inch) are easily inhaled and can penetrate deep into the lungs. These small particles (inhalable particles) are easily generated in large amounts by machine tools. Hand tools produce small amounts of inhalable dust particles. Metal fumes produced by welding and similar heating processes are less than 1 micron in size, and thus are even more easily inhaled.

METALS AND THEIR COMPOUNDS

Metals and their compounds can get into your body in several ways. You can inhale fine metal powders, dust created by grinding and cutting metals, and metal fumes produced by heating metals until they vaporize. You can accidentally ingest them after working by failing to wash your hands before eating or drinking. A few metals and their compounds can be absorbed through the skin; many can cause problems through direct skin contact. The

types of illnesses that metals and their compounds can cause were discussed in chapter 3.

Many metals can affect more than one organ in the body. The section below discusses the hazards of particular metals and their compounds.

Antimony compounds: May be absorbed through the skin. Similar to arsenic poisoning, but to a lesser degree. Not a carcinogen.

Arsenic compounds: May cause skin, lung, and liver cancer; miscarriages and birth defects; skin irritation and allergies, including ulceration; digestive disturbances, hair loss, liver damage, peripheral nervous system damage, kidney damage, and more. Acute ingestion may be fatal.

Barium compounds: If soluble (e.g., barium carbonate), may cause skin, eye, nose, and throat irritation. Inhalation or ingestion may cause heart problems, intestinal spasms, and severe muscle pains.

Beryllium compounds: May cause lung cancer and berylliosis, a severe, allergic pneumonia-like disease that is often fatal or can result in permanent lung damage. May cause chronic skin ulcers.

Boron compounds: May cause loss of appetite, gastroenteritis, liver and kidney damage, testicular damage, and skin rash from chronic exposure.

Cadmium compounds: May cause prostate and lung cancer, miscarriages and birth defects, testicular atrophy, chronic lung, liver and kidney damage, and anemia. Inhalation of cadmium fumes may cause chemical pneumonia.

Calcium compounds: These vary in their toxicity. Calcium fluoride can cause gastrointestinal problems, circulatory and nervous system problems by ingestion. Chronic inhalation or ingestion can cause loss of weight and appetite, anemia, and bone and teeth defects. Calcium carbonate has no significant hazards.

Chromium compounds: Chromium (VI) compounds [chromates and dichromates (bichromates)] may cause lung cancer, skin and nasal irritation and ulceration, skin and respiratory allergies, and birth defects. Chromium metal fumes may cause lung cancer, respiratory irritation and allergies. Chromium (III) compounds such as chrome oxide are only slightly toxic.

Cobalt compounds: May cause skin allergies, asthma, heart problems, and possible lung scarring. Ingestion may cause acute illness. Probable human carcinogen from animal studies.

Copper compounds: May cause skin allergies and irritation to skin, eyes, nose, and throat, and possible ulceration of nasal septum. Acute ingestion causes gastrointestinal irritation and vomiting. Copper fumes may cause metal fume fever.

Gold compounds: Can cause severe respiratory allergies. Chronic inhalation may cause anemia, liver and kidney damage, and nervous system damage.

Iron compounds: Slightly irritating. Ingestion of large amounts can cause poisoning, especially in children. Iron fumes may cause metal fume fever and chronic inhalation may cause siderosis (iron pigmentation of lungs which shows on x-rays), which has no ill effects.

Lead and its compounds: May cause miscarriages and birth defects, acute lead poisoning, anemia, gastrointestinal attacks, liver and kidney damage, brain damage, and peripheral nervous system damage.

Lithium compounds: May cause eye, nose, and throat irritation, and kidney damage. Ingestion can cause poisoning.

Magnesium compounds: No significant hazards. Magnesium fumes may cause metal fume fever.

Manganese compounds: May cause manganism, which resembles Parkinson's disease, from chronic exposure. Symptoms include apathy, loss of appetite, weakness, spasms, impotence, sterility, etc. Acute inhalation of manganese fumes may cause chemical pneumonia.

Mercury and its compounds: May be absorbed through the skin. They can cause both acute and chronic poisoning, primarily affecting the nervous system, gastrointestinal system, and kidneys. Inhalation of large amounts of mercury vapor may cause chemical pneumonia.

Molybdenum compounds: Slight irritants, but not well studied.

Nickel and its compounds: May cause lung cancer or nasal cancer, and can cause skin allergies, and skin and eye irritation. Nickel fumes may also cause metal fume fever.

Palladium compounds: May cause skin irritation.

Platinum compounds: Can cause severe skin allergies, nasal allergies, and platinosis (a severe form of asthma). They may also cause lung scarring and emphysema.

Potassium compounds: Vary in toxicity. Potassium can affect the heart and blood pressure.

Selenium compounds: May be absorbed through the skin. They may cause eye irritation, skin burns, and allergies. Chronic exposure may cause garlic odor, nervousness, nausea, vomiting, hair loss, and liver and kidney damage. Similar to arsenic poisoning. Acute inhalation of selenium fumes and selenium compounds may cause respiratory irritation, chemical pneumonia and bronchitis.

Silver and its compounds: Slightly toxic, except for silver nitrate which is corrosive and can cause severe poisoning. Silver particles imbedded in the skin can cause permanent staining. Chronic inhalation of silver dust or fumes can cause argyria, a permanent discoloration of skin, eyes, nails, inner mouth, throat, and internal organs without any known ill effects. May also cause clouding to the cornea and decreased night vision. High, repeated exposures may cause kidney damage.

Sodium compounds: Vary in toxicity, with sodium cyanide being extremely toxic and sodium chloride (table salt) slightly toxic.

Strontium compounds: Slightly toxic, although ingestion may cause vomiting and diarrhea.

Tin compounds: Slightly toxic in general. Chronic inhalation of tin fumes may cause stannosis, a benign lung reaction which shows up on x-rays.

Titanium compounds: Varying toxicity, depending on the compound. Titanium tetrachloride is corrosive and may cause chemical pneumonia, while titanium dioxide dust was classified as "possibly carcinogenic to humans" by the International Agency for Research on Cancer (IARC) in 2006 on the basis of animal studies. Titanium metal is combustible.

Uranium compounds: Radioactive and may cause lung cancer if inhaled. Soluble uranium compounds such as uranyl nitrate can cause severe kidney damage.

Vanadium compounds: Can cause skin and eye irritation, chemical pneumonia, asthma, bronchitis, anemia, blindness; kidney, intestinal and nervous system damage.

Zinc compounds: Varying toxicity, depending on the particular compound. Zinc chloride is corrosive and highly irritating to the respiratory

system, while zinc oxide is slightly irritating and moderately toxic by ingestion. Inhalation of zinc oxide fumes causes metal fume fever.

Zirconium compounds: Can cause nodules under the skin from skin contact and in the lungs from inhalation.

MINERAL DUSTS

Mineral dusts are found in stone carving and ceramics, and are used as fillers in plastics resins and as abrasives. They are predominantly an inhalation hazard. Minerals that contain asbestos and silica are of major concern, as are man-made mineral fibers (MMMF) such as fiberglass, mineral wool and ceramic fibers. Other minerals used by artists include carbon pigments (paints and inks), carborundum abrasives (sculpture, stone carving, polishing), limestone and marble (carving), and graphite (mold release, drawing). Some minerals also contain metals (see above).

Silica is one of the most common minerals, and comes in crystalline and non-crystalline (amorphous) forms. The most common form of crystalline silica is quartz. Minerals made of quartz include agate, amethyst, chalcedony, chert, flint, onyx and silica flour. Other minerals containing large amounts of quartz include sandstone, granite, clays, feldspars, and slate. Other forms of crystalline silica are cristobalite and tridymite. Fused silica, a synthetic silica, has very small silica crystals.

A natural amorphous silica is uncalcined diatomaceous earth (calcined diatomaceous earth is cristobalite). Synthetic amorphous silicas are fused silica and precipitated silica (silica gel, silicic acid).

Crystalline silica is highly toxic by inhalation, causing silicosis (scarring of the lung tissues) and possible lung cancer. Normally, silicosis develops after 10–15 years of exposure, but very high exposures can cause a rapidly developing silicosis. Tridymite and cristobalite forms of crystalline silica are more toxic than the quartz form. Fused silica is less toxic. Amorphous silica is only slightly toxic, but may cause lung disease at high levels of exposure.

Silicates such as soapstone, talc, vermiculite, and clay contain silica bound to metal and water. They may be contaminated with large amounts of crystalline silica. Silicates by themselves are only slightly toxic, but quartz contamination can cause silicosis.

Asbestos is a magnesium silicate made up of long, microscopic fibers. It is often a contaminant in materials such as talc, soapstone, vermiculite, greenstone, serpentine and French chalk. In the past asbestos had been used in art as a plastics filler, in moldmaking for jewelry, as insulation for kilns, and in papier-mâchés.

Asbestos is extremely toxic, causing asbestosis (scarring of the lung tissue), lung cancer, mesothelioma (cancer of the lining of the chest cavity or the abdomen), and gastrointestinal cancers. Asbestosis can take 10–20 years to develop, lung cancer at least 20 years, and mesothelioma 40–45 years after even brief exposures. Both asbestosis and lung cancer occur more quickly and at higher rates among smokers. For example, the risk of lung cancer among smoking asbestos workers is 50–90 times the rate among non-smoking asbestos workers.

Man-made mineral fibers are substitutes for asbestos. Fiberglass is irritating to the skin and respiratory system. Specialty small-diameter fiberglass can cause mesothelioma in animals; however, artists would not normally use this form. Mineral wool has been found to cause an excess of lung cancer in workers manufacturing it and is a suspect carcinogen. Refractory ceramic fibers have been found to cause cancer in animals and are a possible carcinogen. They are partially converted to cristobalite above 1800°F.

HAZARDS OF VARIOUS MEDIA

Seven

PAINTING AND DRAWING

Painters use many different media: traditional ones like oil, tempera, encaustic, watercolor, gouache, and fresco; and modern ones, mostly acrylic, but including media like alkyd, ethyl silicate, vinyl acetate, and other synthetics. In these media, the artist uses many different pigments, vehicles, solvents (thinners, paint and varnish removers, and the like), varnishes, and other materials.

Common drawing materials include pen and ink, pencil, charcoal, graphite, pastels, oil pastels, and markers. Spray fixatives are commonly used to protect drawings.

PIGMENTS

Most artists are aware of the dangers of lead pigments and don't handle them in powder form because of the danger of inhaling the dust. Even ready-to-use lead paints are very dangerous to handle, and such precautions as carefully washing hands and fingernails after using them are crucial to avoid accidentally carrying the lead paint to the mouth and subsequently ingesting it.

Many artists, however, are not aware that many other inorganic pigments in common use can be hazardous due to the presence of other toxic compounds. (See Table 7-1.) Inhalation of the powdered pigments or of

spray mist from air brushing the paints, or accidental ingestion of the pigments from pointing the brush with your mouth, or eating, drinking, or smoking while working, can result in chronic poisoning. In particular, the chromate pigments and cadmium pigments are known or suspected to cause cancer. The cobalt arsenate form of cobalt violet should never be used because of its extreme acute toxicity.

HAZARDOUS INORGANIC PIGMENTS	
Arsenic:	emerald green (no longer used), cobalt violet (cobalt arsenate type)
Antimony:	true Naples yellow (lead antimoniate)
Cadmium:	all true cadmium pigments
Chromium:	zinc yellow (zinc chromate), strontium yellow (strontium chromate), chrome yellow (lead chromate)
Cobalt:	cobalt violet (cobalt phosphate or arsenate), cobalt green (cobalt and zinc oxides), cobalt yellow (potassium cobaltinitrite), cerulean blue (cobalt and tin oxides)
Lead:	flake white (basic lead carbonate), lead white (basic lead carbonate), cremnitz white (basic lead carbonate), mixed white (basic lead carbonate and zinc oxide), true Naples yellow (lead antimoniate), chrome yellow (lead chromate)
Manganese:	manganese blue (barium manganate and barium sulfate), manganese violet (manganese ammonium phosphate), burnt umber (manganese dioxide), raw umber (includes manganese silicates), Mars brown (manganese dioxide)
Mercury:	vermilion (mercuric sulfide), cadmium vermilion red (cadmium mercuric sulfide)

TABLE 7-1

Other pigments besides those containing heavy metals can be hazardous. Lampblack, for example, can cause skin cancer. In addition, the toxicity of many of the modern synthetic organic pigments is unknown. Some of the metallic driers used with pigments are also toxic because they contain lead

or manganese, although they are only present in small amounts. Cobalt linoleate is the least toxic drier.

VEHICLES

The vehicles and binders used in the traditional media (such as drying oils, egg yolk, gums, casein) are essentially nontoxic. One exception is quicklime, which is both a skin and lung irritant, with inhalation of the dust possibly leading to chemical pneumonia. Wax in encaustic can decompose to produce strong lung irritants if overheated, and the wax vapors are flammable.

Mineral spirits and turpentine are commonly used as thinners and in some oil painting mediums. These solvents are also present in the modern alkyd and solvent-based acrylic paints. As discussed earlier, these solvents are hazardous by skin contact, inhalation, and ingestion and require good ventilation. Odorless paint thinner (odorless mineral spirits) is a safer substitute.

The most common modern vehicle is water-based acrylic emulsion. Many acrylic emulsions contain a small amount of ammonia and formaldehyde. This causes the odor of some acrylic emulsions and may cause irritation of the eyes, nose, and throat if used without ventilation. The formaldehyde may cause allergic reactions in people who are already sensitized to formaldehyde. Formaldehyde may also be present as a preservative in some other water-based media.

OTHER PAINTS

Commercial and non-artist paints are sometimes used by artists. Examples of these include house paints, automotive paints, and epoxy paints. These can contain a wide variety of toxic solvents, preservatives (including mercury compounds), and other chemicals, and should be investigated before being used. Remember that non-artist materials are considered under different labeling regulations than art products.

VARNISHES

Here the solvents are the major hazard. The various solvents used include methyl alcohol and ethanol (shellac varnish), turpentine (damar, mastic,

and cooked oil-resin varnishes), and the lacquer solvents used with pyroxy-lin and other synthetic resins. The major hazard in lacquer thinners is due to the presence of toluene and possibly glycol ethers.

DRAWING MATERIALS

Most common dry drawing materials (pencil, chalk, charcoal, graphite, oil pastels) are not considered hazardous, although you do not want to inhale large amounts of any dust. In particular, the habit of blowing excess dust off the drawing can result in inhalation of large amounts of dust. Pastels can be more hazardous since many pastels contain toxic pigments, just like paints. In recent years, several major pastel manufacturers have been removing the toxic metal pigments from their pastels. However, no pastel dusts should be inhaled.

The use of spray fixatives (or hair spray used by some people) to protect drawings is an inhalation hazard, especially because of the presence of toxic solvents. They should be used outdoors or in a spray booth.

Permanent markers contain solvents, usually xylene or alcohols. There have been instances of liver damage from the long-term use of lots of xylene-based markers without proper ventilation. The alcohol-based markers are less toxic, and water-based markers even safer. Solvent-based drawing inks often contain aromatic hydrocarbons and are highly toxic. They need good ventilation.

Eight

PRINTMAKING

Printmaking methods use a variety of solvents and solvent mixtures. Again, aromatic hydrocarbons (xylene and toluene) and lacquer thinners are hazardous and should be used with adequate ventilation. Benzene (not to be confused with the less toxic aliphatic solvent benzine) should be avoided. Cleaning should be done with the least toxic solvent possible.

Inks used in black-and-white printing usually contain carbon black. Some carbon blacks can be contaminated with polycyclic aromatic hydrocarbons, a known cause of cancer. Avoidance of skin contact and careful washing after exposure is helpful. Common toxic pigments used in printmaking include most of the pigments found in painting. (See Table 7-1.) In addition, lead pigments are much more common in printmaking and include chrome yellow (lead chromate), chrome green or Milori green (lead chromate and potassium ferrocyanide), and molybdate orange (lead chromate, lead molybdate, and lead sulfate). As mentioned previously, the hazards of the synthetic organic pigments have not been well studied, and there is growing concern about their toxicity. Except for the solvent-based silk screen inks, most printmaking inks contain water or linseed oil as a vehicle.

Two decades ago, Nik Semenoff at the University of Saskatchewan in Saskatoon, Canada started a revolution in printmaking with the development of newer and safer printmaking materials, including use of dry copier

toner as an imaging material in all print media, waterless lithography, screen printing inks using a starch-based paste (e.g. wallpaper paste), intaglio mordants based on copper sulfate, common salt and a weak acidifier to etch aluminum and zinc plates, etching intaglio plates by electro-etching, and more. For more information see his Web site (http://homepage.usask.ca/~nis715/) and the bibliography at the end of the book.

SILK SCREEN PRINTING

In silk screen printing with solvent-based inks, the solvents are the biggest health hazards, with exposure coming during screen preparation, printing, drying of the prints, and washup. It is important that the local exhaust ventilation is capable of preventing a dangerous buildup of solvent vapors in the work area. Drying of the prints should be done in a drying rack equipped with local exhaust ventilation or in front of an explosion-proof window exhaust fan. Since most of the solvents are skin irritants, skin contact with them should be avoided as much as possible through use of gloves, especially during washup.

The solvents used depend on the type of ink and the stencil media used. For example, most poster, enamel and fluorescent inks can be washed up with mineral spirits or mineral spirits with about 15 percent added toluene or xylene for the difficult parts. Many companies sell proprietary washups consisting of pure aromatic solvents, like xylene or the more toxic trimethylbenzenes. Lacquer inks and vinyl inks usually require more toxic solvents.

Switching to the use of water-based silk screen inks is the best solution to the many hazards of using solvent-based inks. Since the quality of water-based inks has improved over the years, most schools and colleges are using them.

Nik Semenoff developed a water-based ink based on wallpaper paste that works as a transparent base for screen printing which also can be colored with many pigments and dyes.

The use of lacquer stencils with water-based inks is hazardous unless proper ventilation is present. There are many ways to avoid lacquer stencils, including diazo photoemulsions (not the more hazardous dichromate types, which can cause skin ulcers, allergic reactions, and possible cancer), cut paper stencils, adhesive-based contact paper, etc.

RELIEF PRINTING

Traditional wood-cutting and engraving techniques can cause the potentially crippling carpal tunnel syndrome, which involves pressure on the median nerve running through the wrist due to recurrent and repetitive abnormal bending of the wrist. Symptoms include pain, numbness, and/or pins and needles in the thumb and first two fingers.

Solvents have traditionally been used for the cleanup of oil-based inks. However, cleanup can be done by using first vegetable oil, followed by a soap-based dishwashing liquid (not detergents), thus eliminating the need for hazardous solvents in this step. Nik Semenoff found that some commercial degreasers, followed by water to remove the thin film left behind, can replace solvents for clean-up.

Other relief methods, for example, collage, can also be hazardous if they use toxic solvents and glues. Linoleum etching with caustic soda (sodium hydroxide) can cause severe skin burns.

INTAGLIO

Etching grounds basically consist of asphaltum (pitch in oil or turpentine base), beeswax, and rosin; liquid grounds also contain solvents like benzine, or in the case of some commercial ones, ether or methyl chloroform. The asphalt or pitch is a skin irritant and may cause skin cancer. Rosin dust is a sensitizer, and inhalation can cause hay-fever-type symptoms and possibly asthma. This is particularly a problem in aquatinting. Rosin dust and asphaltum dusts are explosive, and there have been explosions involving rosin dust boxes ignited by sparks from the use of non-explosion-proof parts.

One of the greatest hazards in intaglio is the acid etches. Acids, especially when concentrated, cause severe skin burns. Eye damage from splashes can also be very severe. Remember always to add acid to water, never the reverse. Nitric acid etching of zinc produces highly toxic nitrogen dioxide gas that can dissolve in the lungs to cause chemical pneumonia from heavy exposure, or emphysema and chronic bronchitis from repeated exposures to smaller amounts. Hydrochloric acid (used in Dutch mordant for copper etching) can also cause lung problems. Both of these acids need to be used with local exhaust ventilation. Potassium chlorate, also used in Dutch mordant, is a skin irritant and, when mixed with organic materials, is explosive. Mixing

of the hydrochloric acid and potassium chlorate to produce Dutch mordant releases poisonous chlorine gas. A safer alternative is iron perchloride (ferric chloride). Ferric chloride etching on copper does not produce hazardous gases, but concentrated ferric chloride solutions are corrosive and diluted solutions are skin irritants. Both require gloves and goggles.

During the 1990s, Nik Semenoff developed a much less hazardous etching process for zinc and aluminum that uses copper sulfate, table salt (sodium chloride), and a weak acid such as sodium bisulfate (Sparex), used to clean metals in jewelry. An exhaust hood is still needed since the sodium bisulfate gives off irritating sulfur oxide gases. In addition he developed a method of etching intaglio plates by electro-etching using low voltage current instead of acids. This process, the opposite of electro-plating, uses a weak solution of salt or other appropriate chemical to conduct the current and remove any exposed metal.

Engraving, drypoint and mezzotint involve the repetitive use of tools which can cause carpal tunnel syndrome similar to that caused by wood-cutting. As with relief printing cleanup, intaglio inks can be cleaned with vegetable oil and standard dishwashing liquids (like Joy or Palmolive) or commercial degreasers followed by water instead of solvents.

LITHOGRAPHY

Lithographic drawing materials like lithographic crayons and tusches may contain carbon black, and sometimes solvents are used for thinning. Lithographic etches consist of the relatively safe gum arabic and dilute acid. Prepared etches are safer than handling concentrated acids to make your own. In particular, the extremely toxic hydrofluoric acid should not be used. Rosin dust may cause asthma in some people, and only asbestos-free talc (e.g., baby powder) should be used. Washout of the image is done with solvents, and needs ventilation. Counteretches or fountain solutions containing dichromates should not be used. Dilute acetic acid can be used as a counter-etch, and water with a bit of gum arabic used for a fountain solution. As with relief printing cleanup, lithographic inks can be cleaned with vegetable oil and dishwashing liquids, instead of solvents.

Metal plate processing often uses acid counteretches and vinyl lacquers containing highly toxic solvents to fortify the image for long runs. These

vinyl lacquers should not be used unless adequate local exhaust ventilation is present.

Semenoff's waterless lithography method uses ordinary caulking silicone on ordinary aluminum plates to avoid use of hazardous water-based counteretches and fountain solutions.

PHOTO TECHNIQUES

Photolithography, photoetching, and photo silk screen techniques are common today. Due to their hazards, carbon arcs, once common in printmaking studios, have been mostly replaced with other sources of ultraviolet radiation for exposure. Carbon arc electrodes consist of carbon, tar, pitch, and rare earth fillers with a copper coating. When lit, the carbon arc produced toxic carbon monoxide, nitrogen oxides, ozone, and toxic metal fumes. The gases and fumes, especially ozone and nitrogen oxides can cause severe chronic lung problems, including emphysema after repeated exposure. One problem is that dangerous amounts of fumes can be inhaled without noticeable discomfort. Carbon arcs must be directly vented to the outside by an overhead or canopy hood. In addition, carbon arcs produce large amounts of ultraviolet light that can cause severe eye damage if UV-absorbing goggles or hand shields are not used. Walls should be painted with UV-absorbing zinc oxide to reduce reflection of ultraviolet light. Using light sources other than carbon arcs is highly recommended.

The traditional photoetching process used KPR Photo-Resist, which contained ethylene glycol monomethyl ether acetate (methyl cellosolve acetate). This solvent affects the blood, liver, nervous system, and reproductive system. The KPR developer and dye contained toluene, another toxic solvent.

The high toxicity of these chemicals led to the development of alternative photoetching methods. Some use solvents. Others use presensitized plates. The Image On process, which has become common, uses a photopolymer film with acrylate monomer, and soda ash (sodium carbonate) as developer. Gloves are required since acrylates are skin irritants and sensitizers, and soda ash is alkaline. Ventilation is not needed with this process.

Photolithography can involve the use of toxic solvents. In addition, the classic gum-bichromate method involves the use of highly toxic dichromate solutions, which can cause skin ulcers, allergies, and possibly cancer.

Photo silk screen can use direct emulsions or indirect emulsions. Direct emulsions involve either ammonium dichromate or the much less toxic diazo types, or adhering presensitized films to the screen. The screens are then exposed and developed. Indirect emulsions involve adhering sensitized transfer screens after exposure. Chlorine bleaches, which are skin, eye, and respiratory irritants, are often used to remove the photoemulsions. Local exhaust ventilation is needed with chlorine bleach. Periodate-based emulsion removers are safer although they are skin irritants and oxidizers.

Nine

CERAMICS

Hazards in ceramics fall into three basic categories: the hazards of clays, the hazards of glazes and colorants, and the hazards of the firing process.

CLAYS

Clays contain silicates and varying amounts of crystalline free silica (SiO_2). Inhalation of silica dust from handling the clay in dry form can lead to silicosis ("potter's rot") and lung cancer. Symptoms may take years to develop and include shortness of breath, decreased chest expansion, and increased susceptibility to infections. Eventually, severe scarring of the lungs can result. Inhaling large quantities of kaolin dust can also cause lung scarring.

Many low-fire clays and slip-casting clays contain talc, which can be contaminated with asbestos. This is especially true of New York talcs (NYTAL). Inhalation of asbestos over years of exposure can cause lung cancer, mesothelioma (cancer of the lining of the chest or abdominal cavity) and asbestosis, a form of lung scarring. Some companies have introduced talc-free clays and asbestos-free talcs. In 2007, the Arts and Creative Materials Institute (ACMI) asked manufacturers complying with its standards to replace NYTAL talc in art and craft materials because of evidence it contains asbestos.

The most hazardous operations are the mixing of clay dust, and the breaking up of dry grog. Installation of local exhaust ventilation, using wet clay, and wearing toxic dust respirators are recommended precautions. The contamination of the studio with dry clay dust is also a major hazard, requiring careful cleanup by wet mopping or using a vacuum cleaner with high efficiency HEPA filters.

GLAZES AND COLORANTS

Glazes also contain free silica, often in the form of flint, silica, feldspar and talc, which contribute to the risk of developing silicosis and lung cancer.

In addition, glazes contain toxic metals such as lead, barium, and lithium. Among glaze materials, those containing lead are the most toxic. The use of lead frits decreases but does not eliminate the hazard since many lead frits are fairly soluble in stomach acid. We have seen cases of lead poisoning from both raw lead glazes and lead frits. We recommend not using lead. Food and drink containers made with lead may leach lead into food or drink. Other toxic glaze materials include asbestos and alkali oxides.

Many of the colorants contain toxic metals like antimony, chromium, manganese, uranium, cadmium, and vanadium. Nickel compounds are skin sensitizers and known cancer-causing agents. Cadmium, chromates (lead chromate, zinc chromate, and iron chromate), and uranium oxide may cause lung cancer.

The mixing of glazes from the powders and spraying of glazes are the most hazardous steps. NIOSH-approved N100 respirators should be worn when mixing glazes. Spraying should only be done in a spray booth exhausted to the outside. Special precautions are needed with solvent-containing glazes.

FIRING

During the firing process, toxic fumes and gases are produced. During bisque firings, toxic carbon monoxide, sulfur dioxide and formaldehyde can be released from the clays. Fluorine, chlorine, and sulfur dioxide can be released from the breakdown of the raw glazes to the oxides, and some metals such as lead, cadmium, and others can vaporize during the firing

process. Gas-fired kilns can produce large amounts of carbon monoxide gas, especially during the reduction stages.

Salt glazing, which involves the throwing of wet salt into a heated kiln containing the bisque ware, produces clouds of highly toxic hydrochloric acid. Using sodium carbonate (soda ash) is safer. Raku firing involves firing the ware with a low-fire raku glaze in a kiln, removing it while still hot, and then placing it into containers of sawdust, leaves or similar material for a reduction phase. This process produces large quantities of smoke. Raku firing should be done outdoors away from air intakes and often needs special ventilation.

All indoor kilns—both electric and gas fired—must be ventilated. A window exhaust fan might suffice for small electric kilns but overhead canopy hoods are preferred. Direct vent systems developed by the Orton Ceramic Foundation also provide good ventilation. Gas kilns should also have canopy hoods with powered exhaust and a carbon monoxide alarm.

Potters have developed cataracts from looking in the kiln peephole over a period of years. This is due to the infrared radiation produced when objects are heated to high temperatures. Infrared goggles or a hand-held infrared shield should be used (shade number 2 or 3).

Ten

● ● ● ● ● ● ● ● ●

STONE, PLASTER, CLAY, AND WAX SCULPTURE

STONE

Sculptors use a variety of techniques to work stone, including chipping, grinding, and carving. Some hazards are obvious—for example, the danger of eye injury from flying chips. This is why sculptors should always wear protective goggles when chipping or grinding.

But there are also long-term dangers from working with certain stones—that of silicosis and possible lung cancer. Known to many workers are "grinder's consumption" or "stone-mason's disease," silicosis results from the repeated inhalation of dust containing free silica. As previously noted, silicosis affects breathing capacity and resistance to respiratory disease, and results in scar tissue in the lungs.

Stones containing large amounts of free silica include quartz (100 percent silica), granite, sandstone, brownstone, slate, jasper, opal, amethyst, onyx, and often soapstone. Other stones that may contain some free silica include diabase and serpentine.

Soapstone, serpentine, and greenstone often contain asbestos as a contaminant. Inhalation of asbestos can cause lung cancer, mesothelioma (cancer of

the lining of the chest and abdominal cavity), and asbestosis. Avoid asbestos-containing stones.

You should wear a NIOSH-approved N95 toxic dust respirator when carving stones. If the stone contains silica, wear a N100 toxic dust respirator.

If you work with pneumatic tools, other dangers are present. The vibration can cause "white fingers" or "dead fingers," a circulatory system disease also known as Raynaud's phenomenon. This particularly happens when the hands are chilled; permanent disability can result after repeated exposures. Frequent work breaks, comfortable hand grips on the pneumatic tools, and keeping your hands warm are some ways to combat "white fingers." In addition, the noise from the pneumatic equipment, unless muffled properly, can cause hearing loss.

PLASTER

Plaster of Paris (calcium sulfate) is irritating to the eyes and slightly irritating to the respiratory system. When working with large amounts of Plaster of Paris dust, a NIOSH-approved N95 dust respirator should be worn. Some additives, such as lime, can be much more hazardous.

One serious problem that has occurred with plaster casting is severe burns from the casting of body parts. In several instances, children and adults making plaster casts of hands or arms have been severely burned due to excess building of heat during the setting process. This process should never be done with children.

CLAY

There are two basic types of modeling clay: water-based and oil-based. The hazards of regular wet clay and its dust are discussed in the previous chapter. Oil-based modeling clay is less hazardous than wet clay, although some people might be allergic to some of the components in the oil-based clay.

Self-hardening and oven-hardening modeling clays (e.g., Fimo, Sculpey) are based on polyvinyl chloride. There is controversy about the hazards of phthalates used as a plasticizer in polymer clays, but there is no evidence of toxic effects in children using them. Overheating can cause decomposition to highly irritating hydrogen chloride gas. They should not be heated in an oven used for food and the oven should be vented to the outside.

WAX

Natural waxes such as beeswax and petroleum waxes such as microcrystalline wax and paraffin wax are by themselves not hazardous. However, when they are heated, both fire and decomposition problems can occur. Wax should never be heated with an open flame or on a hot plate with an exposed element. Overheating can cause the wax to decompose into strong lung irritants such as acrolein and formaldehyde. You should always use a heat source with fine temperature control and heat the wax to the lowest workable temperature to minimize vaporization and decomposition of the wax.

Chlorinated waxes, especially polychlorinated terphenyls, have sometimes been used as a foundry casting waxes. These waxes are extremely dangerous and may cause a severe skin disease called chloracne, liver damage, and possible reproductive damage and cancer. They are chemically related to polychlorinated biphenyls (PCBs) and should never be used.

Solvents are often used to remove wax. Some books have recommended such extremely dangerous solvents as carbon tetrachloride and benzene. A less toxic solvent is benzine (VM&P Naphtha) or odorless mineral spirits. A kneader eraser can also be used.

Eleven

WOODWORKING

Woodworkers are subject to a large number of occupational health problems resulting from exposure to the woods, especially tropical woods, solvents, adhesives, noise, and vibration.

Many woods can cause skin irritation and allergies; such woods include South American boxwood, cocobolo, ebony, American and African mahogany, mansonia, rosewood, walnut, East Indian and other satinwoods, and western red cedar. See Table 11-1.

Chronic inhalation of sawdust can cause chronic respiratory diseases. In particular, cocobolo, ebony, African mahogany, mansonia, rosewood, and stainwood can cause respiratory irritation and allergies. Beech, iroko, western red cedar, and teak can cause severe asthma. South American boxwood, cork oak, and redwood can cause an acute illness resembling pneumonia; it appears a few hours after exposure with symptoms of shortness of breath, dry coughing, chills, sweating, fever, and weight loss. A person with this usually recovers from a first attack without any ill effects but repeated exposures can cause lung scarring and decreased lung capacity.

Workers in hardwoods are also at higher risk than the rest of the population for developing nasal and nasal sinus cancer, especially adenocarcinoma.

This disease develops in 7 in 10,000 woodworkers annually, usually occurring forty years after first exposure. It is not known whether this is also true for workers in softwoods.

Paint strippers and finishes contain many different toxic solvents, including toluene, methyl alcohol, methylene chloride and—up to 1978—benzene (benzol), which can cause leukemia. Other health hazards faced by woodworkers include toxic preservatives (such as pentachlorophenol, arsenic compounds, and creosote—all of which may cause cancer and reproductive problems), adhesives (e.g. epoxy resins, solvent-based contact adhesives), vibration from pneumatic tools, and noise from woodworking machines and pneumatic tools.

Safety hazards in woodworking include injuries due to missing machine guards on woodworking machines, damaged equipment, or using the wrong type of machine for a particular cutting operation. Tool accidents are often caused by dull tools or improper use. Other hazards include electrical shock and fire hazards from faulty or inadequate wiring, and fire hazards from accumulation of wood or sawdust.

Precautions include: ventilation for solvents; dust collectors for dust-producing machines; vacuuming sawdust after work (not dry sweeping); wearing goggles when using machines that create dust, and a face shield with goggles underneath for machines that produce wood chips. Noise-reducing measures include shielding or isolating noisy machines, mounting them on vibration isolators, as well as PPE including ear muffs or ear plugs. All machinery should be kept in good repair; and all woodworking machinery should be equipped with the proper guards. General shop safety measures include not wearing ties, long loose hair, loose shirt sleeves, dangling necklaces, and so forth which could catch in machinery and keeping all electrical equipment and wiring in good repair. Extension cords that could be tripped over and are electrical hazards should be replaced by appropriate mounted electrical outlets that are equipped with GFCIs.

TOXIC WOODS

Wood	Reaction	Site	Potency	Source	Incidence
Bald cypress	S	R	+	D	R
Balsam Fir	S	E, S	+	LB	C
Beech	S, C	E, S, R	–	LB, D	C
Birch	S	R	–	W, D	C
Black locust	I	E, S, N	–+	LB	C
Blackwood	S	E, S	–	D, W	C
Boxwood	S	E,S	–	D,W	C
Cashew	S	E,S	+	D'W	R
Cocobolo	I,S	E,S,R	–+	D,W	C
Dahoma	I	E,S	–	D,W	C
Ebony	I,S	E,S	–	D,W	C
Elm	I	E,S	+	D	R
Goncalo aves	S	E,S	–	D,W	R
Greenheart (Surinam)	S	E,S	–+	D,W	C
Hemlock	C	R	?	D	U
Iroko	I,S,P	E,S,R	+++	D,W	C
Mahogany (Swietenia)	S,P	S,R	+	D	U
Mansonia	I, S	E,S	–+	D,W	C
	–	N	+	D	U
Maple	S,P	R	–+	D	C
(C. Corticale mold)					
Mimosa		N	?	LB	U
Myrtle	S	R	–	LB,D	C
Oak	S	E,S	–	LB,D	R
	C		?	D	U
Obeche	I,S	E,S,R	–+	D,W	C
Oleander	D,T	N,C	—	D,W,LB	C

Wood	Reaction	Site	Potency	Source	Incidence
Olivewood	I,S	E,S,R	−+	D,W	C
Opepe	S	R	+	D	R
Padauk	S	E,S,N	+	D,W	R
Pau ferro	S	E,S	+	D,W	R
Peroba rosa	I	R,N	−	D,W	U
Purpleheart		N	−	D,W	C
Quebracho	I	R,N	−	D,LB	C
	C		?	D	U
Redwood	S,P	R, E, S	−	D	R
	C		?	D	U
Rosewoods	I,S	R,E,S	—	D,W	C
Satinwood	I	R,E,S	−+	D,W	C
Sassafras	S	R	+	D	R
	DT	N	+	D, W, LB	R
	C		?	D	U
Sequoia	I	R	+	D	R
Snakewood	I	R	−	D,W	R
Spruce	S	R	+	D,W	R
Walnut, Black	S	E,S	−	D,S	C
Wenge	S	R,E,S	−	D,W	C
Western red cedar	S	R	−+	D,LB	C
Willow	S	R,N	−	D,W,LB	U
Teak	S,P	E,S,R	−	D	C
Yew	I	E,S	−	D	C
	DT	N,C	—	D,W	C
Zebrawood	S	E,S	−	D,W	R

TABLE 11-1.

Reaction	Site	Potency	Source	Incidence
I irritant	S skin	+ Slight probability	D dust	R rare
S sensitizer	E eyes	– Moderate probability	W wood	C common
C Naso-pharyngeal cancer	R respiratory	–+ High probability	LB leaves bark	U unknown
	C cardiac	— Extreme probability		
P Pneumonitis alveolitis	N nausea, malaise			
(hypersensitivity pneumonia)				
DT direct toxin				

Source: This table is reprinted with the permission of its author, Robert Woodcock, RN, BSN, CEN.

Twelve

PLASTICS SCULPTURE

Plastics are used in every part of our lives with few harmful effects that we know of. But the processes used to make and fabricate plastics can be very dangerous. Many occupational diseases are found among plastic workers. And sculptors using these processes are subject to the same diseases.

The degree of hazard depends on whether you are making the plastic or are working with the finished plastic (e.g., sanding, cutting, carving, vacuum-forming, and similar activities).

Plastics consist of large numbers of long chain-like molecules made from smaller molecules (called monomers) linked together. These long chainlike molecules are called polymers, and the process of linking the monomers together is called polymerization. In thermoplastics, the polymers lie side by side and can move when heated to fill different shapes. In thermosetting plastics, on the other hand, the long polymeric molecules are joined together or "cross-linked" by smaller molecules or by heat. The process of turning thermoplastics into thermosetting ones by cross-linking is called curing. Heating thermosetting plastics does not change their shape.

The greatest hazards arise when you are working with the monomers, solvents, fillers, catalysts, and hardeners used in making plastics. Many of the monomers in particular are toxic. This is what you are doing when you are working with casting, laminating, and foam processes.

The hazards involved in working with finished plastics come mostly from the methods used to work the plastic. Overheating or burning of plastic can result in the release of toxic gases from the decomposition of the plastic. This can occur during sawing or machining. Heating of plastics can sometimes result in the release of unreacted monomer, plasticizers, or other chemicals that are trapped in the plastic. Plastic dusts created in the sawing, sanding, and polishing of plastics can sometimes create lung problems. And the glues and cements used to bond plastics often contain toxic solvents and plastic monomers.

In general, you need good ventilation or respiratory protection when working with plastics monomers or when heating or machining finished plastics. Respirators should be NIOSH-approved, with N95 filters and OV (organic vapor) cartridges, unless otherwise specified below. See chapter 27 on Personal Protective Equipment. With these factors in mind, let's look at the hazards involved in working with particular plastics.

ACRYLICS

Methyl methacrylate (MMA) monomer or combinations of MMA with acrylic polymers can be used for casting and laminating. When combined with a catalyst (e.g., benzoyl peroxide) and heated, the mixture cures to a clear solid.

Methyl methacrylate is a skin sensitizer and irritant, and its vapors cause nausea, loss of appetite, headaches, and lowering of blood pressure. Benzoyl peroxide, like most peroxides, is flammable, explosive, a skin irritant, and a skin sensitizer. Peroxides are also very damaging to the eyes, so care should be taken to avoid contact with the eyes.

The main hazards in working with the finished acrylic sheets and blocks (plexiglass and lucite) are inhalation of the dusts or heat decomposition products (MMA monomer and, at higher temperatures, carbon monoxide), and in the use of acrylic glues and cements. Cements consist of pure solvents (methylene dichloride, ethylene dichloride, trichloroethane), or acrylic chips dissolved in these solvents, or of acrylic monomers, and have the same hazards as are involved in polymerizing these monomers, as discussed above. All of the above types of cements require good ventilation to the outside.

POLYESTER RESINS

Polyester resins used for casting and laminating are very hazardous and require excellent ventilation or respirators. These are also called fiberglass resins because fiberglass is used for reinforcement. The normal resin consists of a nontoxic polyester dissolved in styrene monomer that acts as a cross-linker. To cure the resin, a catalyst (methyl ethyl ketone peroxide or benzoyl peroxide) is added. Some polyester resins also contain MMA monomer to give a clear casting resin.

Styrene monomer is an aromatic hydrocarbon similar to toluene or xylene, and, like these solvents, is highly toxic. Styrene is a strong irritant to the skin, eyes, and respiratory system and a powerful narcotic, and may cause liver and nerve damage from repeated exposure.

Methyl ethyl ketone peroxide (MEKP) is flammable and explosive in pure form, but is diluted with dimethyl phthalate for normal use. It should not be allowed to dry out and should not be heated. Methyl ethyl ketone peroxide can also cause blindness if splashed in the eyes; goggles should always be worn when using it.

EPOXY RESINS

Epoxy resins are used in laminating, casting, and are ingredients in certain glues and lacquer coatings. They consist of two components: an uncured epoxy resin and a hardener. The uncured epoxy resin is a skin irritant, sensitizer, and suspected cancer-causing agent.

The hardeners, especially amines, are strong sensitizers and irritants in minute quantities, and have been a major source of adverse reactions among users. During the curing process, large amounts of heat are produced that can cause dangerous fuming of the hardener. Overheating of the cured resin during sawing, sanding, and such activities can produce irritating decomposition products. Handling of epoxies requires careful precautions to avoid skin contact and inhalation.

POLYURETHANES

Polyurethanes are used in several forms. Urethane rubber is used as a flexible mold; urethane foam can be used for sculptures or cast. Polyurethane resins come in two forms: two-component systems and one-component

systems. The two-component systems consist of an isocyanate, and a polyol or polymer that also contains catalysts and other additives. The one-component system is a capped polymer with isocyanates built in, and are air or moisture cured.

The diisocyanates, toluene diisocyanate (TDI) or diphenyl methane diisocyanate (MDI), used to make polyurethanes are highly toxic. Inhalation of isocyanates can cause severe lung problems, with symptoms of breathlessness, chest discomfort, and reduced lung function. Exposure to high concentrations has caused, within minutes, severe lung irritation and coughing spasms. Massive exposure may also lead to bronchitis, bronchial spasms, and/or pulmonary edema (chemical pneumonia). Small amounts can cause severe acute and chronic asthma. Isocyanates can also cause skin and eye problems.

The catalysts used are irritating to the eyes, lungs, and upper respiratory tract, and may cause liver and kidney damage, skin sensitization and irritation. Fluorocarbon blowing agents used with foams may cause loss of feeling, unconsciousness, and heart arrhythmias at high concentrations.

Obviously making polyurethanes is very hazardous. In casting polyurethanes, have local exhaust ventilation (e.g., spray booth) or wear an approved respirator. Do not spray polyurethane resins unless you are wearing a supplied-air respirator (e.g., SCBA).

VINYL POLYMERS

These include polyvinyl chloride (PVC), polyvinyl acetate (PVA), PVC/PVA copolymers, and polyvinyl alcohol. They are thermoplastics and can be heat-molded, vacuum-formed, and so forth. In heat welding of PVC at high temperature, care must be taken to avoid breathing toxic hydrogen chloride fumes released from the decomposition of PVC. In the past, contamination of polyvinyl chloride by vinyl chloride monomer was a serious hazard since vinyl chloride monomer causes liver cancer in humans. A NIOSH-approved respirator with AG (acid gas) cartridge and N95 filter should be worn.

POLYSTYRENES

Polystyrene is available as sheets that can be cut and shaped, as molding pellets that can be fused, as foam sheets (Styrofoam) that can be cut with hot wire cutters, and as expandable polystyrene beads for foam molding.

Cutting or sawing of factory-fresh or very large slabs of Styrofoam releases the colorless, odorless gas methyl chloride, and can release any trapped styrene monomer. In small amounts, methyl chloride can cause symptoms of drunkenness; in large amounts, dizziness, staggering, and even death. It is also a suspected carcinogen and teratogen.

Open flames should be avoided when using expandable polystyrene beads since they contain flammable pentane gas. Some styrene cements used to cement Styrofoam contain styrene monomer.

OTHER PLASTICS

Room-temperature-vulcanizing (RTV) silicone rubber is a common mold-making material. It is available as both a two-component system and a one-component system. The two-component system uses peroxides as a curing agent. These are irritants and sensitizers, and they are flammable. The one-component system cures by interacting with atmospheric moisture and usually gives off acetic acid vapors during curing. These can cause respiratory irritation.

Rubber cement, used in paste-up, contains natural rubber dissolved in low-boiling petroleum distillates, usually hexane until the late 1980's. The rubber-cement thinner was also usually hexane. Nowadays, the less toxic heptane is usually used. n-Hexane can cause nerve damage as discussed in chapter 4. Good ventilation is needed. Rubber cements containing heptane are safer, but still require ventilation.

Fluorocarbons (e.g., Teflon, TPFE) are safe unless heated to decomposition. The decomposition products can cause polymer fume fever, with symptoms that are very similar to a severe case of the flu. Moderate heat, for example lit cigarettes, can create this problem.

ADDITIVES

There are many different types of additives used in plastic resins, including fillers, plasticizers, and pigments. We shall only comment on a few of the more hazardous.

Fiberglass is commonly used in laminating. It is very irritating to the skin and causes many fine cuts that make it easier for other chemicals to cause irritation. Dust respirators should be worn when sanding plastics containing

fiberglass, since the glass dust is irritating to the lungs. Some modern special-ized fiberglass materials are similar in size to asbestos fibers and have caused cancer in animals. This fiberglass, however, is not readily available.

Many fillers contain free silica, and inhalation of the dust should be avoided. Probably the most hazardous substance to use is asbestos. Inhala-tion of even small amounts of asbestos dust can cause cancer. In general, many additives are hazardous, so skin contact and inhalation of vapors or dusts should be avoided.

Thirteen

METALWORKING

METAL CASTING

Most sculptors send out large pieces to a commercial foundry to be cast into metal. A few do their own metal casting; this is particularly popular at art schools. The lost-wax process of metal casting is often used for casting small pieces. The commonest metals and alloys used are bronze, aluminum, brass, pewter, iron, and stainless steel. Gold, silver, and sometimes platinum are used for casting small jewelry pieces.

Mold-making techniques for metal casting use sand and, with some modern techniques, phenol-formaldehyde or urea-formaldehyde resins as binders. Formaldehyde is a strong lung irritant, may cause asthma, and causes nasal cancer in animals. In addition, the resin can decompose from the heat of the casting process to produce toxic phenolic, and/or ammonia vapors. The hexamethylenetetramine used as a catalyst for the resin is a strong skin, ear, eye, nose, and throat irritant and a skin sensitizer. Good ventilation is needed with these resin sands. Protection is also needed against the silica content of the sand.

In the lost-wax process, the wax pattern is covered with a casting investment containing plaster and cristobalite, a highly toxic form of silica that has caused silicosis in jewelers. The cristobalite can be replaced with 30-mesh

sand and plaster, which is much safer. Then the wax is burnt out in a burnout kiln, which requires ventilation due to the highly irritating wax decomposition products. A variation of the lost-wax process uses polyurethane foam or styrofoam to make the positive mold. Decomposition of the foam during the casting process can release toxic gases, including hydrogen cyanide.

In the casting process, the metal is melted and then poured into the mold. The fumes of many of these metals and alloys are toxic. The metal fumes may cause an acute disease called metal fume fever. This is especially true of zinc oxide fumes, but oxides of copper, iron, magnesium, and nickel can also cause metal fume fever. Symptoms are very similar to those of the flu—chills, fever, nausea, weakness, and aches—and appear a few hours after exposure. Metal fume fever lasts about a day and a half, but recovery is complete.

Other health problems can also result from exposure to metal fumes. Inhalation of the lead fumes from bronze (or from lead casting) can cause lead poisoning. Other toxic metals include nickel, which can cause allergic reactions and possible lung or nasal cancer; manganese, which can cause chemical pneumonia or manganism—which is very similar to Parkinson's Disease; and chromium, which can cause lung cancer. In particular, the common practice of using junk metals for casting can be very dangerous since these may be coated with lead pigments, mercury-containing paints, cadmium, and the like.

Another problem is the carbon monoxide produced from incomplete combustion of fuels used for melting the metal, and from the burning of sea coal and other organic materials found in the molding sand. This is a problem during the pouring.

The melting furnace requires a canopy hood exhausted to the outside and there should be good ventilation for the pouring operation.

Another hazard in casting is the large amount of heat released. Unless workers are shielded from the heat, they may develop heat-stress diseases. In addition, the infrared (IR) radiation produced can cause burns unless the skin is covered. Unless proper goggles are worn, repeated exposure of the eyes to IR radiation may cause infrared cataracts. Removing the mold after the casting is complete can also involve the risk of inhalation of silica dust.

Molten metal splashes on the skin can cause severe burns. Molten metal splashes on bare cement can cause miniature explosions with flying cement particles due to vaporization of the water trapped in the cement. Wear protective clothing, shoe coverings, face shield, and goggles. Cement floors should be covered with at least 4 inches of sand.

FORGING

Cold forging uses a wide variety of hammers, mallets, anvils, and similar tools to change the shape of metal. Hot forging involves the heating of the metal to make it easier to shape. Both types of forging create huge amounts of noise, which can damage people's hearing. Some precautions to diminish the noise hazard include having good tools, isolating the forging areas from other people, and wearing proper hearing protection.

Hot forging involves the burning of gas, coke, or other fuels. The forge needs to be ventilated with a canopy hood to exhaust the carbon monoxide produced. This hood will also reduce heat buildup. Infrared goggles should be worn for protection against infrared radiation.

SURFACE TREATMENT

Surface treatment of metals can involve mechanical treatment (chasing, repousse) with hammers, engraving with sharp tools, etching with acids, photoetching, electroplating and electroforming, metal coloring (patinas). Many of these have been discussed in other chapters.

Electroplating and electroforming with gold and silver often use cyanide salts, which can be fatal even from ingestion of small amounts. In addition, accidental mixture of acids and cyanide solution will produce deadly hydrogen cyanide gas. This is hazardous through both skin absorption and inhalation; death can occur within minutes. We recommend against electroplating with cyanide solutions. Instead, send artwork out to a commercial shop. (If you must use cyanide solutions, do so only in an efficient laboratory hood, have a cyanide antidote kit available at all times, and be close to a hospital.)

A variety of chemicals are used to color metals. Some are applied cold, others hot. Many of these are toxic by themselves—for example, lead and arsenic compounds—while others can give off extremely toxic gases when heated. For example, potassium ferricyanide solutions give off hydrogen

cyanide gas, and sulfide solutions give off hydrogen sulfide gas. Very good ventilation is needed for metal coloring and we would recommend against using arsenic compounds or heating potassium ferricyanide or sulfide solutions.

FINISHING PROCESSES

Cleaning, grinding, filing, sandblasting, and polishing are some final treatments for metal. Cleaning involves the use of acids (pickling). This involves the hazards of handling acids and of the gases produced during the pickling process (such as nitrogen dioxide from nitric acid). Grinding can result in the production of fine metal dusts, which can be inhaled, and heavy flying particles, which are eye hazards.

Sandblasting—more correctly called abrasive blasting—is very hazardous, especially if sand is used. Inhalation of fine silica from abrasive blasting with sand can cause a rapidly developing silicosis in a couple of years. Sand should be replaced with glass beads, aluminum oxide, or silicon carbide. Foundry slags should only be used if chemical analysis shows no silica or dangerous metals such as arsenic or nickel. Good ventilation or respiratory protection is needed for abrasive blasting.

Polishing with abrasives such as rouge (iron oxide) or tripoli can be hazardous since rouge can be contaminated with large amounts of free silica and tripoli contains silica. Good ventilation of the polishing wheel is needed.

Fourteen

WELDING

Physical hazards in welding include the danger of fire, electric shock from arc-welding equipment, burns caused by molten metal sparks, and burns caused by excessive exposure to infrared, visible, and ultraviolet radiation. For example, sparks from arc welding can travel up to 40 feet.

Infrared radiation generates large amounts of heat, which can cause burns, headaches, fatigue, and eye damage. Ultraviolet radiation can cause sunburn; repeated exposure may lead to skin cancer. Electric arc welders in particular are subject to pink eye (conjunctivitis), and some have cornea damage from exposure to the UV radiation.

Chemical hazards depend on the type of welding technique and on the metals being welded. Oxyacetylene torches produce carbon monoxide, which ties up the blood's hemoglobin, and also unburned acetylene, which is a mild intoxicant. In addition, commercial acetylene contains small amounts of other toxic gases and impurities.

Metal welding, particularly arc welding, produces enough energy to convert the air's nitrogen and oxygen to nitrogen oxides and ozone. Nitrogen dioxide is highly irritating to the eyes, nose and respiratory tract. Exposure to large amounts can cause chemical pneumonia, emphysema, and even death. Ozone is an eye, nose and throat irritant and it is a severe lung irritant, causing chemical pneumonia, hemorrhage, shortness of breath, headache, and drowsiness. Chronic exposure can cause chronic bronchitis and premature aging of lung tissue. Plasma arc cutting is even more

dangerous since it operates at much higher temperatures and produces more fumes and noise. Avoid plasma arc cutting.

If welding is carried on in the same area where degreasing solvents (chlorinated hydrocarbons) are present, phosgene gas can be produced by the action of ultraviolet radiation on the chlorinated hydrocarbons. Even minute amounts of phosgene gas, an odorless poison gas used in World War I, can be deadly, and its effects often don't appear for hours after exposure.

Metal fumes are generated by the vaporization of metals, metal alloys, and the electrodes used in arc welding. The hazards of metal fumes have been discussed in the previous chapter on metal casting, and can include metal fume fever, lead poisoning, and other ailments. In addition, fluoride fluxes produce fluoride fumes. These fumes dissolve in the lungs to produce hydrofluoric acid, which is highly corrosive and can cause severe burning of the lungs besides affecting teeth, bones, skin, and other parts of the body.

Many metal dusts and fumes can cause skin irritation and sensitization. These include brass dust (copper, zinc, lead, and tin), cadmium, nickel, titanium, and chromium. In addition, there are problems with welding materials that may be coated with various substances. For example, many metals such as scrap metal are coated with lead paint, mercury-containing antifouling paint, and the like.

Precautions for welding include: local exhaust ventilation for welding fumes and gases; personal protective equipment to protect against radiation, welding sparks, and molten metal splashes; and fire precautions.

Personal protective equipment needed with welding includes protective leather gloves, long-sleeved 100% wool or flame-retardant cotton shirts and pants, leather apron (and leather leggings and sleeves for arc welding), welding goggles and face shield (welding helmet for arc welding) with shade numbers appropriate for the type and intensity of welding. For arc welding, a fireproof ultraviolet radiation screen should be placed around the welding area to protect the eyes of other people in the area.

Fire precautions include safe storage and handling of oxygen and fuel cylinders, removal or covering combustible materials or solvents from the welding area, welding on a fireproof surface, and having a fire extinguisher on hand.

Fifteen

JEWELRY AND ENAMELING

JEWELRY

Many jewelry techniques are identical to those of metal sculpture, but on a smaller scale. These include the lost-wax method of casting gold, silver, and platinum, and fabrication and finishing processes.

Because of the lower melting points of gold and silver, these metals are not welded but are brazed at a lower temperature. Silver soldering in particular can be hazardous. The lowest-melting silver solders can contain up to about 30 percent cadmium. Cadmium fumes can cause chemical pneumonia from a single overexposure. In one example, a person died in 1967 from inhaling cadmium fumes when brazing with a silver solder containing cadmium. Chronic exposure can cause kidney damage, chronic lung damage, lung cancer, and possibly prostate cancer. We know of several cases of kidney damage due to cadmium-containing silver solder in art jewelers and teachers. Cadmium-containing silver solders should be replaced with cadmium-free solders.

Fluoride fluxes are commonly used with silver solders. Fluoride fumes can cause respiratory irritation, including nosebleeds and ulceration. Borax fluxes are safer (but not fluoborate fluxes).

Sulfuric acid solutions or Sparex solutions (sodium hydrogen sulfate) are used to clean metal. Concentrated sulfuric acid is corrosive to skin, eyes, and respiratory system. Preferably, use the less toxic Sparex—though Sparex solutions are also acidic and can cause dermatitis. In addition, heating the acid solutions releases sulfur dioxide gas, a lung irritant. Many asthmatics in particular are sensitive to sulfur dioxide.

Because of the high cost of gold and silver, electroplating is popular. This can be extremely hazardous due to the presence of cyanide salts in gold and some other electroplating solutions. As discussed under metalworking, we recommend against using cyanide electroplating solutions. (If you must, do so only in an efficient laboratory hood, have a cyanide antidote kit available at all times, and be close to a hospital.)

ENAMELING

Most copper enamels available in the past were lead-based, although lead-free enamels are now commonly being sold by major manufacturers. Lead poisoning can occur from inhalation or ingestion of the lead enamel powders, from spraying, and possibly from firing of the enamels.

Enamels can contain other toxic metals besides lead, including nickel, manganese, chromium, and cobalt. Uranium oxide, which is radioactive, was banned as an enamel colorant in 1984 by the Nuclear Regulatory Commission.

Precautions include using lead-free enamels, wearing a NIOSH-approved N95 toxic dust mask when mixing or applying enamel powders, spraying enamels in a spray booth, providing enameling kilns with exhaust ventilation, and good housekeeping.

Heating enamels gives off infrared (IR) radiation, and exposure over a period of years has caused infrared cataracts in enamelists. Wear infrared goggles when using enameling kilns.

Sixteen

STAINED GLASS AND GLASSBLOWING

STAINED GLASS

One of the main hazards in stained glasswork is lead poisoning. We know of several diagnosed cases among stained glass workers—both among those using lead came and those using the copper-foil technique. Both techniques involve soldering with lead/tin solders, and there is the danger of inhaling the lead solder fumes, especially if the solder (and lead came) are overheated, as can happen with torches or overly powered electric soldering irons. In addition, the settled lead fumes can coat surfaces and be transferred to hands and to the mouth. Since the copper-foil technique uses large amounts of solder, this technique can involve an even greater risk. With lead came, there is the additional risk of inhalation or accidental ingestion of lead dust from cutting or sanding the lead came. This can be particularly a hazard if you eat, drink, or smoke while you're working, or don't wash up carefully after work. Remember that other family members can also be at risk if you work at home. In the 1980s, an eighteen-month-old child developed lead poisoning as a result of being present when her parents were doing their stained glass work in the kitchen.

Lead solders should be replaced with lead-free and antimony-free solders.

Acid fluxes (zinc chloride, muriatic acid) can cause skin burns, and the fumes are strong respiratory irritants, and can cause bronchitis from high exposures. More likely is the development of chronic bronchitis from repeated inhalation of small amounts of the acid fumes. The fumes from other fluxes are also irritating to the lungs, but to a lesser extent. Inhalation of rosin core flux fumes may cause asthma. Ventilation is needed for both the soldering and flux fumes (e.g., working at a bench in front of a window with a window exhaust fan at work level).

Hydrofluoric acid used for glass etching is highly poisonous. It can cause severe and painful burns, especially under the fingernails. One problem is that there is no burning sensation until several hours after exposure. Inhalation causes severe respiratory irritation and possible chemical pneumonia. It can also affect the bones and teeth. Fluoride pastes are safer to work with, although they produce hydrofluoric acid in solution. Gloves should always be worn and proper ventilation provided. Zephiran chloride solution or calcium gluconate gel should be available as an antidote.

Stained glass can involve many other techniques to color and decorate the glass. Many different patinas are used on the lead came. Copper sulfate is highly toxic by ingestion; skin contact may cause dermatitis, and inhalation may cause congestion and perforation of the nasal septum. Antimony poisoning often resembles arsenic poisoning. Silver nitrate is moderately corrosive to the skin and respiratory system, and highly corrosive to the eyes, and can cause blindness. Selenium dioxide, sometimes used as a patina, is a skin irritant. In combination with strong acid it can produce the highly poisonous gas hydrogen selenide.

GLASSBLOWING

Making your own glass from the raw materials is very dangerous because of the hazards of the raw materials: lead compounds, silica, colorants, and so forth. These hazards are similar to those of ceramics when people mix their own glazes (see chapter 9). The development of pre-mixed, pelletized batches makes this process less hazardous. A safer procedure used by many glass artists is to buy scrap glass (cullet) and melt it in the furnace.

Gas-fired furnaces require canopy hoods to exhaust carbon monoxide and any gases emitted from the glass raw materials. Infrared goggles are needed to protect eyes against the large amounts of infrared radiation produced, which can cause "glassblower's cataracts." Heat is a major hazard in glassblowing and glass artists should take precautions against heat stroke and other heat-induced illnesses.

A variety of chemicals are used for coloring and decorating glass. Many are applied to the hot glass and can be vaporized to produce toxic fumes. For example, zinc fuming can cause metal fume fever. Other metals can produce more serious poisoning. Etching glass with hydrofluoric acid and abrasive blasting have been discussed earlier.

Seventeen

TEXTILE ARTS

The textile arts include a variety of processes, including spinning, weaving, crocheting, knitting, dyeing, and photoprinting.

FIBER ARTS

Most of the hazards in the fiber arts come from dust problems. This is particularly a hazard in early stages of processing like spinning, where fiber dust is present. Most fiber dusts can cause respiratory irritation and sometimes allergies when regularly inhaled. Cotton, flax, and hemp dusts can cause brown lung or byssinosis after years of exposure. In its early stages, symptoms of shortness of breath, chest tightness, and increased sputum flow appear only when a person returns to work after a few days' absence. This stage is reversible. In more advanced stages, symptoms are very serious and are present all the time. At this stage the disease is not reversible and resembles chronic bronchitis and emphysema.

Imported animal fibers, especially goat hair from the Mid-East and Central Asia, carry the risk of anthrax, a serious bacterial disease due to the presence of anthrax spores. This has two forms: a skin form and an inhalation form ("wool sorter's disease"). The inhalation form is usually fatal; in 1976 a California weaver died of respiratory anthrax. All imported wool or

yarn from countries where anthrax is common should be decontaminated, preferably before being sold.

Other hazards with fibers or fabric include respiratory allergies or irritation from synthetic materials due to the possible presence of formaldehyde resins, physical strain from constant uncomfortable positions in weaving, and the use of toxic chemicals (e.g., fire retardants).

DYEING

Hazards in dyeing come from the dyes, mordants, and other dyeing assistants. Direct dyes used for cotton, linen, and rayon in the past were made from benzidine or benzidine derivatives, all known carcinogens. Studies have also shown that the dyes made from these chemicals can cause bladder cancer. Silk kimono painters in Japan who used these dyes, for example, have a high rate of bladder cancer. This may in part be due to their habit of pointing their brushes with their lips. All-purpose household dyes contain a mixture of direct, acid, and basic dyes and, in the past, also contained benzidine-type dyes, which have been shown to be carcinogenic. The hazards of the dyes being used now have not been well studied.

Fiber-reactive dyes, including cold-water dyes, can cause severe respiratory allergies, usually after several years of exposure. This can include asthma, "hay fever," swelling of the eyes and face, and similar ailments. People who have developed an allergy to these dyes usually cannot work with them anymore.

Pre-reduced or pre-solubilized vat dyes are caustic to the skin and respiratory system. Lye (sodium hydroxide), caustic soda, and sodium hydrosulfite used as dyeing assistant with vat dyes are corrosive to the skin, eyes, and respiratory system.

Azoic or naphthol dyes come in two parts, a "fast salt" and a "fast base." They may cause dermatitis and hyperpigmentation. Their long-term effects have not been adequately studied.

The long-term effects of many acid dyes, used for silk and wool, have also not been adequately studied. Many food dyes, which are usually acid dyes, have been banned because studies showed they caused cancer in animals. Acetic acid, formic acid, and sulfuric acid, sometimes used as dyeing assistants

with acid dyes, can cause eye and respiratory irritation and skin burns. Glauber's salt (sodium sulfate), used with acid dyes, is not very toxic.

Basic dyes, used for wool, silk, and some synthetics, may cause allergic responses in some people.

The long-term hazards of natural and synthetic mordant dyes have not been adequately studied. However, many of the mordants used with these dyes can be hazardous. In particular, sodium or ammonium dichromate can cause allergies, burns, and skin ulcers, and are probably human carcinogens. Inhalation of the powder may also cause perforation of the nasal septum. Other mordants are also toxic, especially copper sulfate, ammonia, and oxalic acid.

BATIK

Wax vapors are flammable and wax should never be heated with an open flame or hot plate with an exposed element. When over-heated, the wax decomposes to release highly irritating formaldehyde and acrolein fumes. Heat wax to the lowest temperature that is effective. Use a hot plate or electric frying pan with fine temperature control. Wax decomposition is also a problem when ironing out the wax. This process should be well ventilated. If you use solvents to remove the wax, do not use the extremely toxic carbon tetrachloride. Instead, use odorless mineral spirits with good ventilation, or send your piece to the cleaners.

PHOTOPRINTING

The ferric ammonium citrate and potassium ferricyanide used in blueprinting (cyanotype) are only slightly toxic by themselves. The silver nitrate used in brownprinting (Van Dyke process) is moderately corrosive by skin contact and inhalation, and is highly corrosive to the eyes and may cause blindness. Silver nitrate should only be sprayed in a spray booth or while wearing a NIOSH-approved full-face respirator with a N95 dusts and mists filter.

Carbon arcs, once commonly used as a source of ultraviolet light, produce highly toxic ozone, nitrogen oxides, and carbon monoxide, as well as UV light. In addition, the potassium ferricyanide used in blueprinting will react with the ultraviolet radiation from the carbon arc to produce poisonous hydrogen cyanide gas. Carbon arcs should not be used as an exposure source, but replaced with less hazardous sources of ultraviolet light for exposure.

Eighteen

● ● ● ● ● ● ● ● ●

PHOTOGRAPHY

Many of the chemicals used in photographic processing can cause severe skin problems, and, in some cases, lung problems through inhalation of dusts and vapor. The greatest hazard occurs during the preparation and handling of concentrated stock solutions of the various chemicals. Protective gloves and goggles (to protect against splashes in the eyes) should be worn when mixing and handling photographic solutions. An eyewash fountain (not eyewash bottles) should be present and, in the area where concentrated solutions are mixed, an emergency shower. Special care should be taken to avoid skin contact with powders and to avoid stirring up dusts that can be inhaled. Use a glove box (see pages 118–119) or NIOSH-approved N95 toxic dust respirator when mixing powders. Good ventilation is important to get rid of vapors and gases, especially from the fixer.

Simple black-and-white processing includes developing, stop bath, fixing, and rinsing steps. The developer often contains hydroquinone and Metol (Monomethyl p-aminophenol sulfate), both of which can cause skin irritation and allergic reactions. Many other developers are even more toxic. Developers are also toxic by inhalation of the powders and ingestion, causing methemoglobinemia and cyanosis (blue lips and fingernails due to oxygen deficiency). These are dissolved in an alkaline solution containing sodium hydroxide, which can cause skin irritation and even burns. Tongs

should be used so that hands are never put into the developer. If skin contact does occur, the skin should be washed copiously with water and then with an acid-type skin cleanser.

The stop bath consists of a weak solution of acetic acid. The concentrated glacial acetic acid can cause burns; inhalation of the stop bath vapors can irritate the breathing passages and throat. Potassium chrome alum, sometimes used as a stop hardener, contains chromium and can cause ulcerations, especially in cuts and nasal membranes, and allergies.

The fixer usually contains sodium sulfite, acetic acid, sodium thiosulfate (hypo), boric acid, and potassium alum. Hypo and the mixture of sodium sulfite and acids produce sulfur dioxide, which is highly irritating to the lungs. Asthmatics are often very sensitive to sulfur dioxide. Potassium alum, a hardener, is a weak sensitizer and may cause some skin dermatitis.

Many intensifiers (bleaches) can be dangerous. The common two-component chrome intensifiers contain potassium dichromate and hydrochloric acid. The separate components can cause burns, and the mixture produces chromic acid. Its vapors are very corrosive and may cause lung cancer. One common bleach, potassium chlorochromate, also produces chlorine gas if heated or treated with acid. Handling of the powder of another intensifier, mercuric chloride, is very hazardous because of possible mercury poisoning. Mercuric chloride is also a skin irritant and can be absorbed through the skin. It should not be used.

The commonest reducer contains potassium ferricyanide. If it comes into contact with heat, concentrated acids, or ultraviolet radiation, the extremely poisonous hydrogen cyanide gas can be released. Otherwise, it is only slightly toxic.

Many toners contain highly toxic chemicals. These include selenium, uranium, sulfide or liver of sulfur (corrosive to skin and breathing passages), gold and platinum (allergies), and oxalic acid (corrosive). Sulfide toners also produce highly toxic hydrogen sulfide gas, and selenium toners produce large amounts of sulfur dioxide.

Hardeners and stabilizers often contain formaldehyde, which is poisonous, very irritating to the eyes, throat, and breathing passages, and can cause dermatitis. It also causes nasal cancer in animals. Some of the solutions used to clean negatives contain harmful chlorinated hydrocarbons.

Color processing involves many of the same chemicals that are used in black-and-white processing. Developers also contain dye couplers, which can cause severe skin problems, and some solutions contain toxic organic solvents. Formaldehyde is a common ingredient of some color-processing systems.

NON-SILVER PHOTOPROCESSES

Nontraditional photographic processes not based on silver as the image former have become popular. The most common are cyanotype, the Van Dyke process, and platinum and palladium printing.

Cyanotype, or blueprinting, as it is often called, produces a blue iron compound by: 1) sensitizing paper or fabric with a mixture of ferric ammonium citrate and potassium ferricyanide; 2) exposing the sensitized material to ultraviolet light; 3) developing it with water; and 4) fixing with diluted hydrogen peroxide solution or potassium dichromate. The light source can be sunlight, sunlamp, quartz lamps, or carbon arcs. Use hydrogen peroxide rather than potassium dichromate to fix the image. Do not use unvented carbon arcs.

The Van Dyke process (brown printing), produces a brown color by: 1) applying ferric ammonium citrate and silver nitrate solution to fabric or paper; 2) exposing with a light source; 3) developing with water; and 4) fixing with a solution of hypo (sodium thiosulfate). Gold chloride toning is sometimes done.

Silver nitrate is moderately corrosive by skin contact or inhalation, and highly toxic by ingestion. Eye damage can be very serious. Gold chloride is moderately toxic by inhalation and skin contact, causing a high rate of allergic reactions. Wear gloves and goggles when handling silver nitrate and its solutions. Do not spray silver nitrate solutions. Use hypo solutions with general or local exhaust ventilation.

Platinum prints are produced by: 1) sensitizing paper with a solution of ferric oxalate, potassium chloroplatinite or platinum chloride, oxalic acid and potassium chlorate; 2) exposing to light; 3) developing with a saturated potassium oxalate solution; and 4) clearing the print with a series of hydrochloric acid baths to remove any ferric salts. Toning can be done by adding mercuric chloride, lead oxalate, or potassium phosphate to the developing bath. Aftertreatments may include uranium or gold toning, or intensifying

with a potassium ferricyanide bleach followed by toning in a platinum salt/ phosphoric acid solution. Palladium printing replaces platinum salts with palladium salts.

Overall, platinum and palladium printing use a wide variety of toxic metals and corrosive acids and oxalate salts. Soluble platinum salts are highly irritating by inhalation, and moderately so by skin contact or ingestion. Inhalation of small amounts of platinum salts can cause a very severe asthma, called platinosis. Palladium salts are less toxic, but less is known about their effects. Gold salts may cause skin and respiratory allergies, but less so than platinum salts. Mercury compounds, lead compounds, and uranium compounds are highly toxic by inhalation. Mercuric chloride is also corrosive by skin contact. Oxalic acid and oxalate salts are corrosive by skin contact, inhalation, and ingestion. Concentrated hydrochloric acid is corrosive by skin contact and inhalation. Dilute solutions are irritating. Potassium chlorate is a strong oxidizing agent, and can cause fires in contact with solvents, glycerin, or other combustible materials. Potassium chlorate produces chlorine gas in combination with hydrochloric acid.

If possible, buy only liquid solutions. Powders should only be mixed inside a laboratory hood or glove box, or while wearing a NIOSH-approved N95 toxic dust respirator. Wear gloves, goggles, and plastic apron when handling oxalic acid or its salts, or concentrated hydrochloric acid. An eyewash fountain and emergency shower should be available. Avoid using uranium, mercury, or lead toners. Provide local exhaust ventilation for the clearing baths to remove any chlorine gas produced from the interaction of hydrochloric acid in the clearing bath and residual potassium chlorate in the print. Store potassium chlorate away from solvents or other combustible materials.

Kodak recommends at least 170 cubic feet/minute of dilution ventilation for standard photoprocessing. The exhaust opening should be located just above and behind the fixer and stop-bath trays. For darkrooms with several work stations, multiply 170 times the number of fixer trays to get the total amount of ventilation recommended. Toning and color tray processing should have local exhaust ventilation.

DISPOSAL OF PHOTOCHEMICALS

Old or unused concentrated photographic chemical solutions, toning solutions, ferricyanide solutions, chromium solutions, color processing solutions containing high concentrations of solvents, and non-silver solutions should be treated as hazardous waste. A licensed waste disposal service should be contacted for proper disposal. Unused materials may be recycled by donating to arts organizations or, in some cases, schools, as an alternative. Contact your local sewer authority for information about disposing of your photographic solutions.

Alkaline developer solutions should be neutralized by slowly adding the stop bath or citric acid, and using pH paper to tell when the solution has been neutralized (pH 7), before being poured down the drain. Stop bath left over from neutralization of developer can be poured down the drain, once mixed with wash water to dilute it. Fixing baths should never be treated with acid (e.g., mixing with stop bath), since they usually contain sulfites and bisulfites which will produce sulfur dioxide gas in combination with acid. Fixing baths contain large concentrations of silver thiocyanate, well above the 5 ppm of silver ion allowed by the U.S. Clean Water Act. If large amounts of fixer waste are produced (more than a few gallons per day), then silver recovery should be considered. For small amounts, mixing with wash water and pouring down the drain are possible. Local sewer authorities should be contacted for advice.

For septic systems, Kodak used to recommend that photographic solutions (including wash water) constitute a maximum of 1/3 of the amount of household sanitary waste going into the septic system, and not to release more than a few pints at any one time. They no longer make this recommendation since, in some areas, you need a permit to dump photographic wastes into septic systems.

<div align="center">Nineteen</div>

COMMERCIAL AND GRAPHIC ARTS

COMPUTER GRAPHICS

The use of the computer for graphic or commercial art is the most common activity nowadays; in fact computer graphics has to a large extent taken over many of the graphic arts chemical processes. This is especially true of the paste-up and retouching processes.

Using a computer might result in your developing a wide variety of overuse injuries. These overuse injuries are also called work-related musculoskeletal disorders, cumulative trauma disorders (CTDs), repetitive strain/ stress injuries (RSIs), repetitive motion injuries, etc. Overuse injuries from computer use can affect the upper extremities (fingers, hands, wrists, elbows, shoulders, neck) and cause such problems as shoulder tendinitis, epicondylitis (tennis elbow, golfer's elbow), and carpal tunnel syndrome. The first two are inflammation of the tendons of the shoulder and elbow, and the latter is due to inflammation of the carpal tunnel nerve at the wrist.

There are several risk factors for computer overuse injuries. Repetition, from using the computer keyboard or mouse, is one of the more important ones. Working for extended periods of time without rest breaks to give the body time to recover from localized fatigue is another risk factor. Working more than 4 hours a day at the computer—even with rest breaks—is

considered hazardous. Working in awkward positions or holding the same position for long periods of time also increases the risk of overuse injuries. Examples include bending the wrists because the computer keyboard or mouse is at the wrong height, straining the neck to see a computer monitor or video display terminal (VDT) located at the wrong height, and sitting in one position for extended periods of time. Direct pressure on soft tissues of the body can compress the tissues and cause pressure injuries. An example is resting your wrists on the sharp edge of a table.

The following are precautions to help prevent overuse injuries:

1. Posture is often one of the risk factors that can be minimized by adjusting the computer keyboard, monitor, mouse, work table and chair to your own body. The body undergoes the least strain when the neck, arms, hands, back, legs, etc. are in neutral positions. This means that: 1) the head is erect with eyes forward; 2) the shoulders are not elevated; 3) the upper arms are vertical with elbows at the sides; 4) the forearms are horizontal and about 2–3 inches above the keyboard or mouse; 5) the wrists are straight; 6) the back has its natural S-curve; 7) legs are bent at an angle of about 90°; 8) feet are supported on the floor or on an adjustable foot rest; and 9) there is adequate clearance between the knees and the bottom of the work surface.

2. It is important to have frequent rest breaks, especially during intense work. In addition there should be frequent microbreaks of 30 seconds to 1 minute in between to stretch or change positions. This gives the body time to recover from localized fatigue in the muscle groups being exerted. You should stop work as soon as you feel pain.

3. For computer work, the recommended monitor viewing distance is 18–24 inches or whatever is comfortable. You should not be leaning forward.

4. The computer monitor should be at a height so your eye position is about 15° below your horizontal line of sight. Your eyes should be level with the top of the monitor screen.

5. Glare off reflecting surfaces such as a VDT screen can cause headaches and visual fatigue. Directed task lighting is particularly useful

for fine work or for use in combination with VDTs. Rest your eyes frequently by taking them off the screen and looking around.

6. The correct seated working height for computer work is best established with keyboard and mouse just below elbow height. You should have room for your knees and feet without bumping against anything.

7. Computer chairs should be easily adjustable while seated. They should have the following characteristics:

- Adjustable seat height (16–20 inches);
- A seat pan long enough to support the legs without pressing in at the knees, and wide enough to allow comfortable movement. (Seat pan depth of 15–17 inches, a width of at least 20 inches, a backwards tilt of 0–20°, at least 2 inches of padding, and a waterfall or curved front to prevent pressure against the thighs);
- The back rest should support the upper and lower parts of the back. (Height and width of at least 12 inches, with 4–8 inches of height adjustability. There should be an adjustable lumbar support 6–10 inches about the seat pan. The back rest curvature should be convex from top to bottom and concave from side to side. The seat back should be able to have a horizontal adjustment of 2–7 inches. The back rest should have a tilt adjustment of 95–105° relative to the seat pan.);
- Armrests, if desired, should be padded and be adjustable in height. They should not elevate your shoulders. If necessary take the armrests off. (18 inches minimum distance between armrests);
- The chair should have a steady base with 5 legs, should be able to swivel, and be suited to floor surfaces for easy movement; and
- Footrests, if needed, should be adjustable.

TRADITIONAL GRAPHIC ARTS

Traditional graphic arts include such techniques as drawing, painting, retouching, and paste-up of mechanicals. A wide variety of materials is used—including paints, dyes, inks, bleaches, spray fixatives and adhesives, rubber cement, and solvents—which can be applied by pen, brush, swab, marker, aerosol spray can, or air brush.

In the past, rubber cement and rubber cement thinner used for paste-up usually contained large amounts of extremely flammable and highly toxic hexane. n-Hexane can cause dermatitis, narcosis from inhalation of large amounts at any one time, and peripheral neuropathy (inflammation and possible paralysis of arms and legs) from chronic inhalation of large amounts. In the 1980s, many companies replaced hexane with the less toxic (but still flammable) heptane. Good ventilation is needed for rubber cement and thinners.

Paints can be either water-based (water color, acrylic, gouache), solvent-based (alkyd, lacquer), or oil-based. With water-based paints the only concern is with the pigments, as discussed in chapter 6. When painting with a brush, one is concerned about ingestion or getting the paints in cuts. With air brushing, pigments can be inhaled, which is much more hazardous, especially with highly toxic pigments like chrome yellow, zinc yellow, cadmium, and manganese colors. For paints that use solvents, the hazards of solvent inhalation are found with both brush painting and air brush, although air brushing is more hazardous because you are inhaling large amounts of solvents.

Preferably, air brushing should be done in a spray booth. Otherwise, respiratory protection is needed. For water-based paints, you need a NIOSH-approved respirator with a paint spray or N95 dusts and mists filter. For solvent-containing paints, you need a respirator with an organic vapor cartridge and N95 spray prefilter. The use of solvents for cleaning also requires ventilation.

Dyes are used in markers, colored inks, spray markers, and liquid water colors. The hazards of most of these dyes are unknown since few long-term toxicity studies have been carried out. They can be water-based (liquid water colors, water-soluble markers) or solvent-based (permanent markers, spray markers, many colored inks). A wide variety of solvents is used, but the highly toxic aromatic hydrocarbons such as toluene and xylene are among the most common. These require very good ventilation. Alcohol-based markers are safer. If the dyes are sprayed, then a spray booth or respirator with a spray prefilter and an organic vapor cartridge (for solvent types) is essential. The use of bleaches to remove the dyes from the skin is not recommended since the bleach can cause dermatitis. It is better to avoid skin contact in the first place—for example, through the use of barrier creams or gloves.

Spray fixatives and spray adhesives are sometimes used. They are very toxic by inhalation due to the presence of solvents. Toluene, chlorinated hydrocarbons, and petroleum distillates are common as solvents. Petroleum distillates are not usually considered highly toxic unless they contain hexane, but in spray-mist form they may cause chemical pneumonia if substantial quantities enter the lungs. The long-term hazards of the adhesives are not known. However, hairdressers who use aerosol sprays regularly have been found to have a higher rate of chronic lung problems than the rest of the population.

Aerosol spray cans are also explosive and usually flammable. The replacement of freons by extremely flammable gases like propane has caused a great increase in the number of fires in the last decade or so. Whenever possible, aerosol sprays should be replaced by non-aerosol products. Mouth atomizers for spraying are not recommended because of the risk of liquid backing up into the mouth. Large amounts of spraying should be done in a spray booth.

Retouching of drawings, packages, photographs, and the like is another graphic arts technique, although today it has been mostly replaced by computer techniques. It uses all of the materials described above, as well as other materials specifically for photographic retouching. Freon and methyl chloroform (1, 1, 1-trichloroethane) are commonly used for film cleaning. Freon is only slightly toxic, although in large quantities it may cause irregularities in heart rhythms. Methyl chloroform is one of the least toxic chlorinated hydrocarbons, although it can cause narcosis and also has been implicated in heart problems at high concentrations.

Iodine and potassium iodide in water are commonly used as a black-and-white bleach. Iodine is a strong skin irritant and is poisonous if ingested. Ethyl alcohol, which is only slightly toxic, is used as a stopping agent, and thiourea as a clearing agent. Thiourea is suspect as a cancer agent in humans since it causes cancer in animals.

A variety of chemicals is used for color bleaching. One of the most common is potassium permanganate in diluted nitric or sulfuric acids. Sodium bisulfate is the clearing agent. Potassium permanganate is highly corrosive as the powder or in concentrated solutions, and mildly irritating in dilute solution. When diluting the acids, always add the acid to the water, never

the reverse. Wear rubber gloves and goggles. Sodium bisulfate decomposes in acid solutions to produce sulfur dioxide, which is highly irritating to the eyes and respiratory system.

In transparency retouching, potassium permanganate, sulfuric acid, and sodium chloride, or Chloramine-T and acetic acid are used to bleach yellow dyes. Do not add more potassium permanganate solution than specified in the directions because of the danger of producing highly toxic chlorine gas. Similarly, Chloramine-T releases chlorine gas in acid solutions. The Chloramine-T powder is also irritating to the skin, eyes, nose and respiratory system, and causes allergic reactions. Use of all of the above bleaches requires local exhaust ventilation.

Stannous chloride and disodium EDTA are used as a magenta dye bleach. Stannous chloride solutions are skin irritants and the dust is a respiratory irritant. Disodium EDTA is highly toxic by ingestion, causing kidney damage and tetany (irregular muscular spasms of the extremities) due to calcium depletion. Sodium hydrosulfite (sodium dithionite) used in a cyan bleach is flammable and can decompose to produce sulfur dioxide. Sodium cyanide is occasionally used as a bleach. Sodium cyanide causes skin rashes and is extremely poisonous by ingestion and possibly by inhalation. Sodium cyanide reacts with acids to produce the poison gas hydrogen cyanide, which can be fatal by inhalation in minutes. We recommend against using cyanide bleaches. (If you must, do so only in an efficient laboratory hood, have a cyanide antidote kit available at all times, and be close to a hospital.)

Gum arabic solution is often sprayed onto photographs as a fixative. Inhalation of gum arabic can cause "printers' asthma," so called because about 50 percent of the printers who used to spray it became sensitized to gum arabic.

Twenty

● ● ● ● ● ● ● ● ●

ALTERNATIVE MEDIA AND MODERN TECHNOLOGY

The nature of creative expression in the arts results in a materials and processes curiosity, which can involve the artist in experimenting and combining materials and processes in new ways. It is common to see artists incorporating alternative media in their art, as well as experimenting with variant processes.

BIOLOGICAL MATERIALS
Biological materials, such as shell, bone, feathers, fur and other animal materials are sometimes used in collage and sculpture.

Coral, mother of pearl, abalone, and other shells can be shaped by cutting, sawing, or shaving with electric or handsaws; and by using electric grinders or polishers. Hazards involve flying chips and dust, cuts from sharp edges, and respiratory irritation. Inhalation of abalone and pearl dust can cause fever and a pneumonia-like disease, as well as more rarely, ossification and inflammation of tissue covering your bones. Precautions include carefully cleaning the shells, and using wet methods for grinding and polishing. A NIOSH-approved N95 dust respirator can be used while grinding.

Working with feathers can result in "feather-picker's disease" showing symptoms of coughing, chills, fever, nausea, and headaches with initial

exposure. Symptoms are usually alleviated over the long-term, with a minimal tolerance developing in as short as a week. Sometimes moderately toxic pesticides such as naphthalene or the probable carcinogen para-dichlorobenzene are used as mothproofing agents. Precautions with feathers include vacuuming with a HEPA vacuum cleaner prior to handling, and wearing a NIOSH-approved N95 dust respirator. Air out stored feathers that have been mothproofed before working with them. This should be done outdoors. Use safer mothproofing agents or repellents such as cedar oil if possible.

Bone, antler, horn, and ivory should be thoroughly cleaned before carving, because improperly cleaned or raw bones and antlers can cause infections if the material is diseased. This is a particular problem if one has cuts or abrasions on the hands. Materials from the Middle or Far East, also pose the risk of anthrax (see Textile Arts, chapter 17). Other issues include respiratory irritation and allergies, and inhalation of ivory dust can cause an increased susceptibility to pneumonia and other respiratory diseases. All raw bones should be degreased and cleaned with solvents. (See chapter 4 for information on hazards of solvents, and chapter 24 for information on solvent ventilation.) Wet methods should be used for carving, sanding, and grinding and NIOSH-approved N95 dust respirator worn while dry carving.

Some artists have experimented with using dead animals or animal parts, animal and human blood, and biological specimens in their art. Animal specimens can be obtained from road kill, old preserved scientific or taxidermy specimens, and also from local butchers. Some specimens are preserved in hazardous substances such as formaldehyde and other preservatives. Old taxidermy specimens have often been treated with arsenic. We have seen performance art that involves self-cutting or mutilation, and artworks that utilize bacteria growth, or mold and fungus decay as part of the design. Some art works and installations include live animals such as spiders creating webs, and flies or ants that are integral to the art work. Sometimes, artists will use their own body as a template in the art process, for example cutting, undergoing plastic surgery, or other body biologic invasive processes. There is an area of artistic social commentary that can incorporate hazardous chemicals, bioterrorism agents, or their containers.

Hazards of these materials are varied. Dead animals can have all sorts of diseases, which can be transmitted to people, including the Hansa virus,

rabies, anthrax, and other infections. Birds can transmit the West Nile virus. Bites from spiders and other insects can range from irritating to fatal. Both animal and human blood can be infected with diseases that can be transmitted to people. There is a concern with bloodborne pathogens such as Hepatitis B and C, and the HIV virus. Preservatives and pesticides used for specimens can be extremely toxic.

Precautions include not using insects, animals, birds, blood or other biological materials that can be infected with diseases that can be transmitted to people. Old taxidermy specimens should be tested for arsenic, and handled with local exhaust ventilation and appropriate PPE. When using blood or other potentially infectious material for any artwork, utilize "Universal Precautions" which means assuming that the blood is unsafe, and wearing gloves and clean up spills with bleach accordingly. When using animals or insects for art pieces make sure that you understand your particular animal habitat, behavior, and needs in order to care for them, and you, safely.

CHEMICAL AND MATERIALS HAZARDS

While the preceding chapters described many of the material hazards of working with artists' products, sometimes it is hard to recognize hazards. For example, a photographer may decide to capture on film a certain moment, that of a bullet penetrating an apple, a bouquet of flowers detonating, or a vista of a hazardous waste site. While all of these subjects can result in a superb photo, there are hazards associated with the initial subject. Artists must analyze carefully their topic and subject matter, and if you are doing any activities that involve explosion, weaponry, or chemical combinations that result in any kind of reaction (e.g., thermal, combustion, reactive etc.), or if your process takes you to a location that may yield potentially hazardous exposures you must take adequate precautions for these potential exposures.

MODERN TECHNOLOGY IN ART

Increasingly, artists are using modern applications including laser sculpture, holography, neon sculpture, computer art, and photocopiers.

Lasers (Visible light lasers)

Lasers are sometimes used as a form of light sculpture and in making holograms. Laser beam light or radiation can be very intense and can cause eye and skin damage as well as present other hazards, depending on the class of lasers. In addition to hazards from the laser beam, there can be severe electrical hazards from the high voltages involved.

LASER CHARACTERISTICS		
Laser class	Power	Hazards
Class 1	Lowest power lasers	Do not emit hazardous levels of energy under normal operating conditions.
Class 2	Less than 1 milliwatt (mW) radiant energy	Chronic hazards with prolonged viewing. Safe when viewed by unaided eye for up to 0.25 seconds.
Class 3R	1-5 mW.	Chronic eye hazard, and may be acute eye hazards when viewed through optical instruments or when you look directly into the beam. Risk of injury due to a brief, accidental exposure is small.
Class 3B	Less than 0.5 watts.	Acute and chronic eye hazards from viewing the beam directly or viewing specular reflections. Class 3B lasers are also skin hazards; a 150-milliwatt laser can cause third-degree burns.
Class 4	Greater than 0.5 watts.	Acute skin and eye hazards by both direct and scattered radiation. They are also fire hazards.

TABLE 20-1.

Precautions with lasers include: using the lowest power laser that is feasible; making sure that all lasers are labeled with their classification and appropriate warnings, and that warnings are posted on the entrance to areas where lasers are used. All lasers must have a protective housing that prevents exposure (or leakage) to more than Class 1 radiation levels, except when operating the beam. There should be appropriate safety interlocks for higher class lasers, as well as emergency stop switches. Never leave lasers unattended when in operation. Any laser above Class I should have an emission indicator to tell when the laser is energized. Higher classes of laser require more warning systems, and beam attenuators. There should be written procedures for the setup, alignment, and testing of lasers prior to use. Always follow the laser manufacturer's recommended procedures.

Only Class I lasers may be viewed directly. However, as a matter of good practice, no laser beam should be stared at. The laser room should be brightly lit to prevent dilation of pupils. Dilated pupils can result in more radiation exposure. The laser room should have non-reflecting surfaces for general use, and appropriate laser goggles should be worn with Class 4 lasers where there is a hazard from diffuse reflections. All laser operators should have regular eye examinations.

More information on laser safety can be found in ANSI Z136.1-2000, "Safe Use of Lasers." The use of lasers in public is regulated by the Food and Drug Administration's (FDA) Center for Devices and Radiological Health (formerly the Bureau of Radiological Health) under Public Law 90-602, the Radiation Control for Health and Safety Act of 1968. Lasers for use in entertainment, such as light shows where the public is present, are regulated as demonstration lasers. The Office of Compliance of the FDA's Center for Devices and Radiological Health spells out in detail exactly how the laser can be used. In addition to federal regulations, there may be state and local regulations.

Holography

Holography is one art process, that of three-dimensional photography, that commonly utilizes a 3B neon laser. Xylene, perchloroethylene, and other solvents have been used between the photographic plate and glass holder to match the refractive index of glass. Perchloroethylene is a probable human

carcinogen and can cause dizziness, headaches, nausea, and liver and kidney damage. Xylene can cause dizziness, headaches, and nausea. Precautions include the above standard laser precautions. A vibration-free holographic table should be used. All electrical equipment and wiring should be approved for the voltages used and are in good repair. See electrical safety section below. Use xylene rather than perchloroethylene, with dilution ventilation (e.g., window exhaust fan). Keep flammable solvents away from sources of ignition, including the undiffused laser beam. Hologram development uses the same processes as standard photography. See chapter 18 for a discussion of photographic chemical hazards and safety precautions.

Neon Sculpture

Neon sculpture involves evacuating a lead glass tube of desired shape, adding small amounts of neon gas, or mercury, and applying a high voltage across the tube to ionize the neon gas or mercury vapor and achieve the desired luminous effect. To obtain a variety of colors, phosphor-coated neon tubes are used, which convert the ultra-violet radiation from the mercury or neon ions into various visible colors.

The neon tube pattern is drawn on paper and an aluminum screen placed over it, so the hot glass tube can be shaped to the pattern without burning the paper. Do not use asbestos. Shaping the glass tube into the desired shape is done using gas burners and torches. This involves risks of thermal burns, low-level infrared radiation exposure, and fire from the use of fuel gases. Wear protective gloves and infrared goggles (shade 2 or 3). If compressed gases are used, there are also the hazards associated with them. (See the section on compressed gases in chapter 14 Welding.)

If fluorescent phosphor-coated tubes are heated, there is a risk of inhalation of hazardous phosphor powders. Local exhaust ventilation should be used when heating phosphor-coated tubes or a NIOSH-approved N95 respirator worn to prevent inhalation of the phosphor fumes.

Vacuum pumps are used to evacuate the neon tube. Mechanical pumps give off an oil mist, and mercury pumps produce mercury vapor. Do not use mercury pumps. Small amounts of liquid mercury are often added to the evacuated neon tube to achieve a blue color. Add mercury to the neon tube carefully (e.g., with a syringe). A major concern is with possible mercury

spills, since mercury can vaporize easily and is highly toxic. Even small spills can release a lot of mercury vapor. Store mercury in a secure place in a plastic, not glass, bottle. The area where the mercury is used should be sealed, to trap any spilled mercury easily. Working on a tray to contain mercury spills is one way to do this. A mercury spill control kit should be on hand (available from safety supply companies). Do not vacuum up mercury spills, since a very fine mist of mercury vapor will pass through the vacuum cleaner.

When disposing of old neon tubes, carefully remove residual liquid mercury from the tube. This mercury must be disposed of as hazardous waste.

Neon sculpture involves the use of high voltages, which can involve risks of fires from faulty electrical equipment and wiring, electrical shock and arc flashes. This is particularly a hazard with the bombarding transformer, which involves very high voltages. Faults in neon glass tubing could cause implosions, during the bombarding stage to remove impurities and during final evacuation of the neon tube.

Make sure all electrical equipment and wiring are in good repair. All electrical cables, transformers, and connectors should be approved by Underwriters' Laboratories for the voltage being used. All high-voltage equipment should be labeled and properly shielded.

Insulate all high-voltage electrical wiring when possible. Exposed, high-voltage leads should be out of reach of normal contact (e.g., along the ceiling) and marked with a warning sign. The operator and electrical controls should be located behind a transparent, protective shield to prevent access to voltage wires and in case of explosive breakage of the neon tubes. A heavy rubber mat should be placed in front of the testing workbench.

High-voltage electrical wiring inside the transformer mounting box should be straight and short, kept at least 2.5 inches from any metal parts, and well insulated. The mounting box should be grounded. No live electrical components should be accessible to spectators.

Neon tubes, especially those containing mercury, give off ultraviolet (UV) radiation. The glass tube blocks the most dangerous far UV, but some near UV can pass through the glass. Depending on its intensity, the lower end of the near UV radiation could cause some corneal damage, cataracts, skin cancer, and sunburn. Phosphor-coated tubes would absorb most of this UV and convert it into light. The main hazard would be to the neon artist,

especially during bombardment, which uses higher voltages. Wear ultraviolet goggles when working close to operating neon tubes, especially during bombardment. Use the darkest practical shade number.

This above chapter really reveals the huge variety of art materials and processes, and therefore the great range of potential hazards and necessary safety precautions. If artists are experimenting with alternative materials in their work, we suggest that you carefully research and plan all activities, learn about your materials, consider your audience, and only work in such a manner in which your viewers, your co-workers, your studio, and of course you yourself are safe and protected from any hazardous exposure.

Twenty-one

CHILDREN AND ART MATERIALS

Despite concern over lead poisoning in children and attempts to eliminate children's exposure to such lead-containing materials as wall paints and pencils, some children are still being exposed to lead in art classes in schools, community centers, and even in the home. In the past, we found lead-containing pottery glazes and enamels in many elementary schools we visited. Many people mistakenly assume that lead frits are "safe," whereas in actuality many commercial lead frits can dissolve in stomach acids. Other sources of lead in art materials sometimes used with children include silkscreen and other printmaking inks, lead solders, and stained glass.

Examples of lead poisoning in children include a child swallowing stencil paint that contained at least 30 percent lead, and an eighteen-month-old girl developing lead poisoning after being present in the kitchen where her parents were involved in stained-glass work.

Lead, however, isn't the only hazardous art material being used by children. The ingestion of one tablespoon of turpentine can be fatal to a child, and ingestion of two tablespoons of methyl alcohol (found in many shellacs) could have serious toxic effects, possibly including blindness. Other art materials that are toxic by single or repeated ingestion of small amounts include many solvents (paint thinner, kerosene, lacquer thinners, and the like), acids, alkalis, photographic chemicals, dyes, and many pottery glaze ingredients.

Ingestion, however, is not the only way in which art materials can injure children. Skin contact with many art materials can cause burns, irritation, ulcers, and allergies. Examples include solvents, which defat the skin; acids and alkalis, which can cause severe burns; formaldehyde and turpentine, which can cause skin allergies; and potassium dichromate (a natural dye mordant), which can cause skin and nose ulcers. If the skin has cuts or sores, many toxic materials can enter the body through these breaks in the skin's defenses. In addition, many solvents can be absorbed through the skin into the body.

Finally, inhalation of solvent vapors, dusts, aerosol spray mists, and metal fumes can either injure the lungs or be absorbed though the lungs into the bloodstream. Common art materials containing hazardous solvents include turpentine, paint thinner, paint and varnish removers, rubber cement, silk-screen inks and solvents, lacquers and their thinners, shellac, permanent markers, cleaning solvents, aerosol spray cans, and solvent-based glues and adhesives. Hazardous dusts include asbestos, dry clay, glaze ingredients, dye powders, plaster dust, and sawdust. Other toxic art materials children may be exposed to include etching gases, kiln gases, soldering fumes, and gases from photographic developing.

WHAT IS THE RISK?

We believe that children under the age of about twelve should not be exposed to most hazardous materials. This conclusion is based on both physiological and psychological reasons.

First, children are at much higher risk physiologically from exposure to toxic materials than adults. There are several reasons for this. Children and teenagers are still growing and have a more rapid metabolism than adults. As a result, they are more likely to absorb toxic materials into their bodies. With young children this can especially affect the brain and nervous system. Young children also have smaller lungs and are therefore particularly more susceptible to inhalation hazards. Finally, children are at higher risk because of their smaller body weight. A certain amount of toxic material is more concentrated in a child's body than it is in a larger adult body. Therefore, the smaller the child, the greater the risk.

Second, children under the age of twelve cannot be depended upon either to understand the need to carry out precautions or to carry them out

effectively on a consistent basis. Preschool children are likely to put things in their mouths deliberately and then swallow them, thus creating an even greater hazard. Even though older children might not deliberately swallow art materials, there have been several fatalities due to accidentally swallowing turpentine or paint thinner that had been carelessly stored in soda bottles, orange-juice containers, or similar containers. In addition, accidental ingestion can occur by placing contaminated hands in the mouth.

For these reasons, we recommend that children under the age of twelve not be allowed to use art materials that are hazardous by ingestion, skin contact, or inhalation. Junior and senior high school students, although they are still at higher risk than adults, are at an age when they might normally be expected to understand the need for precautions and to carry out precautions consistently. Of course this generalization has exceptions, particularly with mentally retarded or emotionally disturbed children. We would recommend, however, that even junior and senior high school students not use highly toxic materials like asbestos, lead, mercury, and cadmium, since even small exposures to these materials can have severe effects.

WHAT ART MATERIALS SHOULD CHILDREN USE?

Art materials recommended in some children's art books are highly toxic and should not be used by children.

This brings up the question: How can you tell which materials are safe or whether children can work with them safely? Many children's art materials have a label stating that they are "non-toxic." Unfortunately, this label can be misleading since many children's art materials have not been tested for long-term toxicity, including possible cancer. Further, most art material manufacturers do not have toxicologists or other personnel competent to evaluate the hazards of the art materials they are using.

The earliest program we know of that has attempted to ensure the safety of children's art materials is that of the Arts and Crafts Materials Institute, (formerly Crayon, Watercolor and Craft Institute). Art materials carrying their Certified Product (CP) or Approved Product (AP) seal of approval have been "certified by an authority of toxicology, associated with a leading university, to contain no materials in sufficient quantities to be toxic or

injurious to the body, even if ingested." There are undoubtedly other safe children's art materials but we do not have verification of this.

The Labeling of Hazardous Art Materials Act of 1988 requires labeling of all chronically hazardous art materials. If there are hazards, the label must state that the product is not suitable for use by children. Properly labeled art materials carry the statement "Conforms to ASTM D-4236" or the equivalent. The law also gives the Consumer Product Safety Commission the power to obtain a court injunction against any school that purchases toxic art supplies for use in elementary school.

In the late 1980s, the California Office of Environmental Health Hazard Evaluation published a list of art materials that may not be used in grades K-6. An updated list is available at: http://www.oehha.ca.gov/education/pdf_zip/ArtListMay2007.pdf

The following are some recommendations for the safe use of art materials with children:

- Do not allow children to use adult art materials. Use children's art materials with the round AP seal of the Arts and Crafts Materials Institute (ACMI), or use art materials that carry the statement "Conforms to ASTM D-4236" and do not have any warning labels. The round "AP" seal and the octagonal "CL" seal have replaced the older ACMI symbols, e.g. the "AP," "CP," and "HL" symbols. For details on ACMI programs, see amcinet.org.

 Remember, that if donated art materials are unlabeled and not immediately identifiable one must assume that they are not for use by children. We have seen many cases where children's art programs receive generous donations of supplies that contain hazardous chemicals.

- Do not allow children to use solvents (e.g., turpentine, toluene, rubber cement thinner) or solvent-containing materials (solvent-based inks, alkyd paints, rubber cement, permanent felt tip markers, solvent-based glues, aerosol sprays). Instead, use water-based inks, paints, glues, etc.

- Do not allow children to use art materials containing toxic metals

such as arsenic, cadmium, chromates, mercury, lead, manganese, or other toxic metals that may occur in pigments, metal filings, metal enamels, ceramic glazes, metal casting, stained glass, etc.

- Do not allow children to use or create powders. Some powders— such as powdered clay, synthetic dyes, pastels, pigments, glazes, etc.—contain toxic chemicals. But children may experience respiratory irritation from even relatively nontoxic powders such as children's temperas, plaster dust, etc. Either purchase the material in liquid or wet form (e.g., wet clay, liquid paints), or an adult can mix up the powders away from children. For dyeing, use vegetable and plant dyes (e.g., onionskins, spinach, tea, flowers) or food dyes.

- Do not allow children to use corrosive chemicals such as acids, alkalis, photochemicals, etc. Instead of photoprocessing, do sungrams using blueprint paper and sunlight, or use Polaroid cameras.

- Do not allow children to do plaster casting of body parts. Serious burns have resulted from this process.

- Do not allow children to use scented markers. These teach children bad habits about eating and sniffing art materials.

- Clean the art area carefully so that toxic dusts such as clay and plaster do not accumulate where they can be inhaled by children (or the teacher).

- Do not allow food or drink in the art area because of the risk of contamination—and make sure children wash their hands carefully after class. Make sure children do not have exposed cuts or sores on their hands.

- Ventilate all kilns, including electric kilns. Place the kilns in a room separate from the children.

Part Three

SAFETY IN THE STUDIO

KNOW YOUR MATERIALS

In order to know how to work safely with art materials, you must first know what chemicals they contain and the properties of these chemicals. Several sources of information are useful for this purpose, including product labels, Material Safety Data Sheets, and reference sources.

PRODUCT LABELS

Warnings on the label of an art material should be your first alert as to whether the material is hazardous or not. At least this is true if the art material is properly labeled, as required under the Labeling of Hazardous Art Materials Act of 1988. The Labeling of Hazardous Art Materials Act of 1988 requires art and craft manufacturers to determine whether their products have the potential to cause chronic illness, and to place labels on those products that do. However, rather than leaving the criteria for chronic hazards up to individual manufacturers, the law requires that the Consumer Product Safety Commission (CPSC) develop guidelines for chronic hazards. See chapter 1 for more details.

Many artists use products that were originally developed for industry. Examples include screen-printing inks and other screen printing products, plastics resins, ceramics materials, etc. Sometimes these are labeled "For Industrial Use Only." If an industrial product is sold in art supply stores or

other locations where consumers can walk in and purchase it, if the manufacturer advertises it as suitable for making art, or sells it to schools, then it does have to be labeled in accordance with the Labeling of Hazardous Art Materials Act.

If it does not meet these requirements, then the product does not have to be labeled as an art material. As discussed below in the section on Material Safety Data Sheets, if the product is hazardous, it would still have to be labeled with its identity and hazard information under the Hazard Communication Standard of the Occupational Safety and Health Administration (OSHA).

A proper warning label should have the following components:

A Signal Word: The signal word tells you the extent of the hazard. Danger is the most serious, followed by Warning and Caution, respectively. Danger is used for products that are highly toxic by inhalation or ingestion, corrosive or extremely flammable. Warning or Caution are used for substances that are less hazardous. Warning is also used for products that only have chronic hazards. Odorless mineral spirits, for example, a recommended substitute for turpentine or regular mineral spirits, has a DANGER warning because of the ingestion risk.

A List of Potential Hazards: This section lists the known significant acute and chronic hazards under reasonably foreseeable use of the product. The hazards should be listed in order of descending severity and should specify the type of hazard. One brand of odorless mineral spirits, for example, states the following: "COMBUSTIBLE, HARMFUL OR FATAL IF SWALLOWED. HARMFUL BY BREATHING VAPORS. EXPOSURE MAY RESULT IN NAUSEA, HEADACHES OR CONFUSION, INSTABILITY, OR IRRITATION OF THE EYES OR CHEST."

Name of Hazardous Component(s): This contains a list of the common or usual names of hazardous ingredients and known hazardous decomposition products, with acutely hazardous ingredients listed first. If there is no common name, then chemical names should be used. This should include known sensitizers present in sufficient amounts to cause allergic reactions in sensitized individuals. In the above example, the odorless mineral spirits should state "Contains petroleum distillates."

Safe Handling Instructions: This section should include appropriate precautionary statements concerning fire safety, work practices, ventilation, and personal protection. The brand of odorless mineral spirits mentioned above has the following precautions: "Do not use near heat or flame. KEEP OUT OF THE REACH OF CHILDREN. Avoid prolonged contact with skin. Use with adequate ventilation. Use exhaust fan to remove vapors."

First Aid: This section includes recommendations for emergency first aid. For the odorless mineral spirits, the First Aid section stated: "If swallowed, do not induce vomiting. Call physician immediately. In case of contact with eye, rinse with water for 15 minutes. If irritation persists, contact a physician."

Sources of Further Information: This can include referrals to a local poison center, 24-hour emergency number, availability of MSDSs, and other information.

Other Statements: The art material label must carry the statement "Conforms to ASTM D-4236" or a similar statement. If there are warnings, then the label must also state that the product is not suitable for children.

If the art material is imported, it is still supposed to follow the requirements of the Labeling of Hazardous Art Materials Act of 1988. However, in many instances we have found that not to be true. Therefore you should be cautious about imported art materials and request a MSDS on the product from the importer.

MATERIAL SAFETY DATA SHEETS

Under the Hazard Communication Standard of the Occupation Safety and Health Administration (OSHA), manufacturers and importers are required to prepare Material Safety Data Sheets (MSDSs) on hazardous products to provide more detailed information on the hazards and precautions. A major problem is the MSDSs were originally intended for use by health and safety professionals and tend to be very technical. In addition, the quality of most MSDSs left much to be desired, especially in the area of chronic hazards.

One problem is that artists are not entitled to obtain MSDSs unless they are an employee since OSHA just applies to employers and employees. In addition, OSHA does not apply to public employees in states that do not have OSHA-approved state plans. However, most reputable manufacturers will send MSDSs even to self-employed individuals.

The following is the typical format of a MSDS. Manufacturers are not required to use this format as long as all the information specified is present. The MSDS must be in English. Blank spaces are not allowed on an MSDS. If a particular section is not applicable or no information is available, then the section must specify that. OSHA recommends that MSDSs follow the 16-section format established by the American National Standards Institute (ANSI) standard for preparation of MSDSs (Z400.1). The 16 sections are as follows:

1. **Product and Company Identification**
 The identity of the product should be the same name as found on the product label and shipping documents. The MSDS must have the date of preparation, and the name, address, and telephone number of the chemical manufacturer, importer, employer, or other party responsible for preparing the MSDS.

2. **Composition, Information on Ingredients**
 This section must include the chemical and common names of hazardous ingredients. For mixtures that have been tested as a whole, only the ingredients found to be hazardous must be listed. If the mixture has not been tested, all toxic ingredients at a concentration greater than 1 percent must be listed, and all carcinogenic ingredients at concentrations over 0.1 percent. Materials are considered hazardous if they are listed in OSHA's Z list (29 CFR 1910, Subpart Z, Toxic and Hazardous substances), if the American Conference of Governmental Industrial Hygienists has assigned a Threshold Limit Value (TLV) to the material, or if it has been found to be toxic, carcinogenic, irritating, sensitizing or damaging to certain body organs. Unfortunately, the MSDS does not have to list the percentage concentration of each ingredient.
 This section must also have the OSHA Permissible Exposure Limit (PEL), the ACGIH Threshold Limit Value (TLV) or any other exposure limit used by the manufacturer.
 The one exception to listing the chemical names or com-

mon names of hazardous ingredients, according to OSHA, is if the manufacturer claims and is able to document that it is a trade secret. In this case, the manufacturer must state on the MSDS that the identity of the ingredients is a trade secret.

3. **Hazards Identification**

This section will briefly describe the material's appearance and odor, as well as note health, physical, or environmental hazards that may be of concern for emergency response personnel.

4. **First-aid measures**

This section should include information about particular emergency and first aid measures to take with regard to the art material. This section should be written in easy-to-understand language, and there should be a "Notes to Physicians" subsection if such information is available.

5. **Fire-fighting measures**

This section has information on the flammability of the product (e.g., flash point, and upper and lower flammability limits), on types of fire extinguishers needed, and on other special precautions. These data are important when planning for emergencies. See chapter 26 for more information on flammability.

6. **Accidental release measures**

This section refers to emergency procedures in the case of a spill or release of the material and should provide information to emergency personnel that will minimize adverse effects on employees and well as on the environment and surrounding area.

7. **Handling and storage**

It is here that there will be guidelines for minimizing any hazards from storing the material incorrectly. It should include information to minimize handling if appropriate, and certain conditions to avoid such as a specific temperature or inert atmosphere.

8. **Exposure Controls and Personal Protection**

This section will discuss the engineering controls that may be needed when handling the material (like ventilation), and the personal protective equipment needed when there is a potential for exposure above the recommended or regulatory limits. The respirator recommendations should state what type of cartridge should be used. The ventilation section should tell you whether general mechanical ventilation (dilution ventilation) is sufficient, or if local exhaust ventilation is recommended, and if so, what type. This section should also list other recommended personal protective equipment such as gloves, goggles, and protective clothing. Unfortunately, most MSDSs do not tell you what type of glove to use.

Exposure guidelines, such as OSHA PELs and ACGIH TLVs should be included in this section.

9. **Physical and Chemical Properties**

This section should include information on the physical and chemical characteristics such as boiling point, vapor pressure, vapor density, solubility in water, specific gravity, percent volatile, evaporation rate, appearance, and odor. Sometimes the pH is included for aqueous solutions.

Some of this information can be helpful in determining how much will evaporate and how fast. This is especially useful for products containing organic solvents. The percent volatile, for example, can tell you how much can evaporate. The evaporation rate will give you an idea of how long it will take to evaporate. Unfortunately, different manufacturers use different standards, but, in general, low numbers mean it takes longer to evaporate.

10. **Stability and Reactivity**

This section should describe conditions that may result in a potentially hazardous reaction. It is very important if you might heat the product, mix it with other chemicals, expose

it to ultraviolet radiation, etc. It tells you about the product's compatibility with other chemicals, and special conditions to avoid. The stability of the product indicates whether the product can decompose and what conditions can cause this. For example, potassium ferricyanide (Farmer's reducer) can decompose to release hydrogen cyanide gas if heated, exposed to ultraviolet radiation, or, if acid is added.

The incompatibility section tells you what chemicals can react with the product. For example, chlorine bleach is incompatible with ammonia since they react to product a poison gas. This section is very important in determining what materials you should not store near this product.

Hazardous decomposition products tells you what hazardous chemicals can be produced when the product is heated or burned. For example, when you heat or burn Plexiglas, you can produce the irritant methyl methacrylate.

The hazardous polymerization section tells you whether the product can polymerize, and what conditions can cause this.

11. Toxicological Information

This section should include any known health hazard data resulting from animal testing or human experience on the toxicity of the material.

This section should also tell you the routes (skin contact, inhalation, ingestion) by which the product can affect you, the symptoms of overexposure, acute and chronic health effects, emergency first aid measures, and carcinogenicity.

If the product or chemicals in the product have been found to be a carcinogen or probable carcinogen by the International Agency for Research on Cancer or OSHA, or are listed in the National Toxicology Program's Annual Report on Carcinogens, then the MSDS must state so.

The MSDS should also list medical conditions which could be aggravated by exposure to the product.

12. **Ecological Information**

This section should list impacts to the environment that can occur if the material is released to the environment, or in evaluating waste management treatments.

13. **Disposal Considerations**

This section provides information to provide environmental and technical people responsible for waste management.

14. **Transport Information**

Here will be information concerning classification of the material for shipping. Department of Transportation (DOT) classification will be listed here.

15. **Regulatory Information**

This section should contain information regarding the regulatory status of the material, including both OSHA and EPA regulations, and state or other agencies if applicable.

16. **Other Information**

Other information that is relevant, for example, references or other hazard ratings, should be placed in this section.

REFERENCE SOURCES

The bibliography at the end of this book lists a number of references where you can obtain additional information on the hazards of chemicals found in art materials. http://www.osha.gov/dsg/hazcom/msdsformat.html

Twenty-three

SUBSTITUTION OF SAFER MATERIALS AND PROCESSES

Use the safest materials possible. In many instances you can substitute a less toxic material for a more hazardous one without sacrificing quality. Examples are using cadmium-free silver solders to replace cadmium-containing ones; using glass beads, silicon carbide, or aluminum oxide to replace silica sands in abrasive blasting; using zinc white to replace lead white (flake white) pigments; and using lead-free glazes and enamels.

Solvents are another area in which substitution can result in a safer work environment. As discussed in chapter 4, solvents have a wide range of toxicity, and, often, highly toxic solvents can be replaced with less toxic solvents. For example, xylene or lacquer thinners, often used for cleaning silk screens, can usually be replaced with the less toxic mineral spirits (or mineral spirits with about 15 percent added toluene or xylene for hard spots). Chlorinated solvents like trichloroethylene and perchloroethylene can sometimes be replaced by mineral spirits. Lacquer thinner can often be replaced with acetone, which is only slightly toxic (although it is extremely flammable). Methyl alcohol can almost always be replaced by denatured alcohol or isopropyl alcohol. In fact, the least toxic solvents you can use are

acetone, denatured alcohol, isopropyl alcohol, and odorless mineral spirits that have the aromatic hydrocarbons removed.

Sometimes, solvents used for cleanup can be replaced with other materials. One example is the use of vegetable oil followed by a soap-based dishwashing liquid for cleaning oil-based inks in printmaking.

Another type of substitution is to use water-based materials instead of those that are solvent-based. This can be particularly important for schools. Examples are using water-based silk-screen inks, water-based contact cements, and water-based felt-tip markers. Water-based paints such as water color and acrylics would, for example, be safer to use during pregnancy than oil paints requiring turpentine or mineral spirits.

Process changes can also often result in safer procedures. Working with wet processes or materials is much better than working with powders. For example, wet clay or water-based dyes can be purchased instead of dry clay or powdered dyes. Wet grinding techniques can often be used instead of dry grinding. Another example of a process change is to apply paints, finishes, glazes, and the like by brushing or dipping instead of spraying or air brushing.

Finally, chemicals that can cause cancer should not be used. The level of precautions needed to work safely with carcinogens is much more stringent and costly than those required for ordinary toxic chemicals. The main reason for this is that there is no known safe level of exposure to cancer-causing chemicals and therefore exposure should ideally be zero. Examples of carcinogens that should be avoided include asbestos, cadmium fumes, lead and zinc chromate, uranium oxide, benzene, and pentachlorophenol.

One warning about using substitutes. Always make sure the substitute isn't more hazardous than the original, and allow sufficient time to learn how to use the substitute. Substitutes are usually different chemicals with different properties. You have to learn the peculiarities of the substitute. For example, you cannot paint with acrylics in the same manner as you do with oils.

Twenty-four

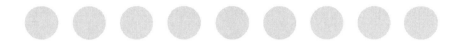

VENTILATION

Ventilation is one of the most important—and most neglected—factors in designing a studio. Ventilation should always be tried before considering respiratory protection. The problem is the definition of adequate ventilation. Many people think that an open door or window or an air conditioner is adequate ventilation. It isn't. You have no control over wind direction with an open window and it does not provide sufficient air movement. The problem with an air conditioner is that it recirculates almost all the air—even on "vent," and does not exhaust any contaminants.

There are two basic types of ventilation: dilution ventilation and local exhaust ventilation. Dilution ventilation involves bringing in clean, outside air to dilute any contaminants to a safe level and then exhausting it to the outside. Local exhaust ventilation involves capturing the toxic contaminants at their source and exhausting them before they get into the air you breathe.

DILUTION VENTILATION
Dilution ventilation is only effective with small amounts of slightly or moderately toxic solvents and gases. Large amounts of solvent vapors or highly toxic solvent vapors would require an enormous amount of air to dilute them, which would be expensive in terms of both fans and energy costs

required to heat or cool the incoming air. Dilution ventilation is not effective with dusts because it stirs them up.

In designing a dilution ventilation system, there are several factors to consider. First, make sure there is adequate make-up air to replace the air being exhausted. Second, make sure that the exhaust fan is located so that clean air passes your face before being contaminated and exhausted (see Figure 24-1). Third, make sure that exhaust outlets and air intakes are located far enough apart so that the contaminated exhaust air cannot reenter the room.

GOOD AND BAD DILUTION VENTILATION

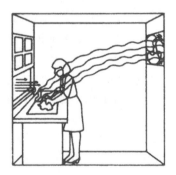

FIGURE 24-1.
Illustration by Sedonia Champlain

DILUTION VOLUMES FOR COMMON SOLVENTS	
Solvent	**Dilution Volume (cu. ft./pint)**
Acetone	11,025
Ethyl alcohol	6,900
n-Heptane	6,900
n-Hexane	61,700*
d-Limonene	298,000*
Methyl ethyl ketone	22,500
Methylene chloride	126,800
Mineral spirits	30,000–35,000
Toluene	190,000*
1,1,1-Trichloroethane	11,400
Turpentine	25,500*
Xylene	33,000

* Not recommended

TABLE 24-1.

The actual size of the fan needed to dilute the contaminants to a safe level depends on the toxicity of the material, and the amount of material escaping into the room in a given time period. For solvents, the amount of dilution ventilation required (Q) can be calculated by the following formula:

Q (cfm: cu ft per min) = # pts evaporated x dilution vol. (cubic ft per pt) x K(safety factor) # minutes of exposure

Where:
- The dilution volume per pint is the number of cubic feet of exhaust air required to dilute the vapor concentration from the evaporation of one pint of a solvent to the Threshold Limit Value (the TLV is the 8-hour average concentration that is supposed to be safe). See Table 24-1 for dilution volumes for common solvents.

- K is a safety factor to allow for uneven mixing of air, being close to the point of solvent vapor production, solvent toxicity, and rate of evaporation. We normally recommend a safety factor of 10, especially since there is controversy about the safety of many TLVs.
- The number of minutes is the time over which solvent evaporation occurs.

For example, an oil painter using 1/2 cup of odorless paint thinner over a period of four hours would only need a fan exhausting about 325 cubic feet per minute. This could be achieved with a simple window-exhaust fan and by setting up the easel, palette and solvent container, about three feet away from the window.

LOCAL EXHAUST VENTILATION

Local exhaust ventilation should be used for such processes as silk-screen printing and cleanup, acid etching, spraying operations, welding, kiln firings, woodworking operations, clay mixing, photographic toning, and the like.

Local exhaust systems consist of a hood to capture the contaminants, ducts to carry the contaminated air to the outside, an exhaust fan, and

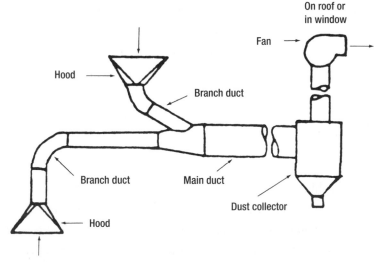

FIGURE 24-2.

sometimes dust collectors to remove dust from the exhausted air. (See Figure 24-2.) In general, local exhaust ventilation is preferred over dilution ventilation because it is more effective, uses less air and therefore has lower ongoing energy costs, and does not expose people to the contaminants even at low levels.

Figure 24-3 shows a variety of common types of hoods. These are a spray booth, a slot hood, a canopy hood, a movable exhaust, and a dust-collecting hood.

A general rule is that the more you enclose the process the better, as shown with the spray booth and the flanges on the movable exhaust for welding.

The hood should be located so that the natural velocity of the contaminant will be in the direction of the hood opening. For example, spray booths exhaust at the rear or top rear because that is the direction of the spraying. Similarly, canopy or overhead hoods are used to capture hot, rising gases from kilns and furnaces. A canopy hood should not be used in situations where you would have your head under the hood because that would place your head in the upward stream of contaminants.

The hood should be placed as close to the source of the contaminant as possible. Otherwise, the contaminants might escape before the hood can capture them. For example, movable exhausts for welding are best used four to six inches from the point of welding, and slot hoods used in silk-screen printing, for example, are usually only effective over a distance less than three feet.

Of course, make sure that there is an adequate supply of replacement air and that the exhausted air cannot reenter the room.

Ducts should be made of materials that won't be affected by the contaminant. To keep air flowing smoothly, ducts should be circular, with as few bends as possible, and the bends should be gradual, not abrupt. With dusts, the duct velocity must usually be at least 3,500 feet per minute to keep the dust from settling in the duct.

There are two basic types of fans: axial or propeller fans, and centrifugal fans (see Figure 24-4). Propeller fans are used for dilution ventilation, while centrifugal fans are used for most other types of ventilation. If the gases, vapors, or dusts being exhausted are flammable, then explosion-proof systems are required.

HOODS FOR LOCAL EXHAUST VENTILATION SYSTEMS

Local Exhaust Ventilation for Art and Craft Processes

CANOPY HOOD

Process: ceramic kiln,
 metal foundry, forging.
Form: vapor, gas, fume, steam
Not ready made.*

Advantages

Captures upward-moving contaminants.

Good for heat-producing operations.

Handles surges of hot air.

Easy to construct.

Designed in various sizes.

Disadvantages

Exposes worker to contaminants
 if he works under hood.

Often used improperly.

Should not be used for dust.

SLOT HOOD

Process: silkscreening, acid etching,
bench welding, soldering.
Form: vapor, gas, fume.
Not ready made.*

Advantages

Has universal applications.

Does not interfere with most processes.

Can cover a long work area: four-foot
 maximum selections are used side
 by side.

Good for processes performed on a work
 bench.

Disadvantages

Work must be kept in close proximity of
 slot opening.

Work-table depth has a 36" maximum.

Can be difficult and costly to construct.

SPRAY BOOTH

and other enclosed hoods
Process: spraying lacquer, paint,
 ceramic glazes, flammable
 materials, highly toxic materials.
Form: vapor, gas, fume, dust.
Ready made.*

Advantages

Completely encloses contaminant.

Safest hood for flammables and highly
 toxic materials.

Conserves materials.

Reduces housekeeping.

Designed in various sizes.

Disadvantages

Cost of operation high.

Requires more space than other hoods.

Requires constant cleaning.

HOODS FOR LOCAL EXHAUST VENTILATION SYSTEMS

Local Exhaust Ventilation for Art and Craft Processes

PLAIN-OPENING HOOD

Process: welding, soldering, art
 conservation.

Form: vapor, as fume.

Ready made.*

Advantages

Can be used in areas where conventional
 hood will not fit.

Can be connected to flexible ducting for
 repositioning to fit work and for several
 alternating locations.

Easy and inexpensive to construct.

Disadvantages

Must be in a range of four to six inches
 from opening for effective capture.

DUST-COLLECTING HOOD

Process: grinding, woodworking,
 polishing.

Form: dust.

Sometimes ready made.*

Advantages

Reduces housekeeping.

Reduces fire hazards.

Disadvantages

Ready-made hoods often ineffective.

Requires constant cleaning.

FIGURE 24-3.

* Ready-made hoods are available in set sizes and are complete with all equipment from manufacturer and
 dealers. Others must be fabricated by a sheet-metal shop.

First appeared in Ventilation: *A Practical Guide*, Center for Occupational Hazards, 1984

Illustration by Sedonia Champlain

BASIC FAN TYPES

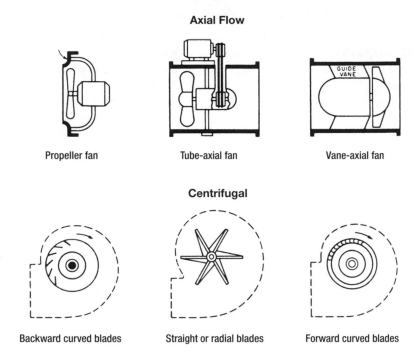

Axial Flow

Propeller fan Tube-axial fan Vane-axial fan

Centrifugal

Backward curved blades Straight or radial blades Forward curved blades

FIGURE 24-4.

STORAGE, HANDLING, AND HOUSEKEEPING

STORAGE

Safe storage of art materials involves simple steps. First, choose appropriate containers. Never store solvents or other chemicals in unmarked containers or food and drink containers like those used for milk, orange juice, and so forth, because of the risk that a child—or even you—might drink the contents by mistake. Avoid breakable glass containers whenever possible. Dyes and other materials that come in small paper bags should be transferred to plastic containers to avoid tears in bags that will release dust into the air. Clay and glaze chemicals in large 100-pound paper bags with rips in the bag should be used immediately or the whole bag placed in a plastic garbage bag. All containers should be labeled.

Second, make sure materials will not fall off shelves. Restraining strips along the shelves can help prevent this. In addition, acids and other corrosive chemicals should not be stored on high shelves because of the danger of the container falling and breaking and splashing the chemical all over the work area and possibly you.

Third, do not store together chemicals that can react with each other. For example, photographic fixing solutions and acids should not be stored next to each other because, in the case of an accident resulting in the mixing of the two chemicals, large amounts of irritating sulfur dioxide gas would be produced. Peroxide hardeners used with plastics resins should be stored separately from organic chemicals because they could react explosively with each other. Material Safety Data Sheets describe the chemical incompatibilities of their products.

HANDLING

Keep all the containers covered to prevent evaporation of solvents, even if you are using them for only a few minutes. Self-closing containers are best. Solvent-containing cans with paint brushes in them can be covered with aluminum foil. An alternative is to place the brushes in a tall, covered spaghetti jar.

Enclosure for mixing powders

FIGURE 25-1.

Powders should be handled in such a way as to minimize dust escaping into the air. Containers should be kept closed. When pouring powders, do so carefully. In many instances, powders can be mixed in a simple, enclosed glove box as shown in Figure 25-1. The box can be made of cardboard and sealed inside with shellac or similar sealant to make it easier to clean. The purpose of the glove box is to prevent dust from escaping.

Always dilute concentrated acids by adding the acid to the water, never the reverse, to prevent acid from splashing into your face.

Personal work practices can also help achieve a safer environment. Do not eat, drink, or smoke in the work area, and always wash your hands after work. Do not use turpentine or other solvents to clean your hands but use soap and water or a safe waterless hand cleanser (obtained from a safety-supply house). (With handwashing, remember it is the friction of washing that is most effective, and that anti-microbiological's main goal is to kill bacteria rather than remove grime and residue.) Keep separate work clothes and change them before leaving the studio or entering living area. Wash them separately from other clothes.

In case of splashes on the skin, rinse with lots of water. If you are using concentrated acids or other corrosive materials, you should have quick access to an emergency shower.

In case of splashes in the eyes, rinse with lukewarm water for at least fifteen minutes and then contact a physician. An eyewash fountain that does not require your hands to operate it is recommended. Contact lenses should not be worn in situations where chemicals can splash in the eyes, unless goggles are worn.

HOUSEKEEPING

If you live and work in the same area, the risk of contaminating living areas becomes greater. You should never work in your kitchen or living areas, but should set aside a separate area just for work. In particular, keep children away from your work area.

One of the biggest problems in housekeeping is dust control. Dust should always be wet-mopped or vacuumed, never swept. Sweeping just stirs

up the dust. Highly toxic dusts like clay dust, asbestos, and lead dust require a special HEPA (high efficiency particulate air) vacuum cleaner because very fine dusts go right through normal industrial vacuum cleaners. Work surfaces should be wet-mopped daily.

Spills should be cleaned up immediately to prevent evaporation of volatile liquids or the spreading of dust. For large toxic and/or flammable liquid spills, do not try to clean them up yourself because of fire and health risks. Shut off flames, evacuate the area, shut off the power from outside the room, and call the fire department. For small spills, use spill control materials available from safety supply companies.

DISPOSAL

Dispose of waste art materials safety. Disposal of large quantities of hazardous chemicals should be done by a waste-disposal service. Substitution, evaporation, neutralization, and recycling are other waste management options.

Sometimes the chemistry department of a nearby university or high school can help you. Do not pour waste solvents down the sink because of the risk of fire hazards, evaporation from drains in other rooms, and contamination of water. Some artists have poisoned their septic-tank system by pouring hazardous chemicals down the drain. Small quantities of volatile solvents (less than a pint) can be disposed of by allowing them to evaporate under a hood or outside.

If local codes allow, nonhazardous aqueous solutions can be poured down the sink. However, this should be done one at a time with lots of water. Acids and alkalis should be neutralized first.

See Table 25-1 for more information on disposal of art materials.

RECOMMENDATIONS FOR DISPOSAL OF ART MATERIALS

ACIDS

dilute solutions Neutralize to pH 7 by slowly adding baking soda (sodium bicarbonate) until bubbling stops. Check the pH with pH paper. Pour down the sink with lots of water.

concentrated solutions	Small amounts (less than a cup) should be diluted by first slowly pouring the acid into water (1:10 ratio), and then neutralizing as above. Gloves, goggles, and protective apron should be worn. Always add the acid to the water. For larger amounts, recycle or use hazardous waste collection.
Aerosol spray cans	Make sure they are completely empty by spraying outside, and then place in garbage.

ALKALIS dilute solutions	Neutralize to pH 7 by slowly adding citric acid or white vinegar using pH paper to indicate when neutral; then flush down drain with lots of water.
concentrated solutions	Small amounts (less than a cup) should first be diluted by pouring the alkali into water (1:10 ratio), and then neutralizing as above. Always add the alkali to the water and wear gloves, goggles, and protective apron. For larger amounts, recycle or use hazardous waste collection.
solid alkalis	Recycle or use hazardous waste collection.

CERAMICS	
clay, minerals	Recycle or place in garbage.
glaze chemicals	Recycle or use hazardous waste collection.
liquid glazes	Recycle if possible. If the glazes contain toxic, leachable metals, use hazardous waste collection; otherwise, place in garbage.

DYES	
powders	Recycle or place in garbage.
solution	Pour down drain with lots of water. If the dye bath is acidic or alkaline, neutralize as above.

GLUES AND CEMENTS	
water-based	Allow to dry, and place in garbage.
solvent-based	Allow to evaporate in safe place, and place in garbage.

METALS AND COMPOUNDS	
metals, alloys	Recycle or place in garbage.
compounds	Recycle or use hazardous waste collection for toxic metals; garbage for others.

PAINTS, VARNISHES, STAINS

water-based	Recycle or allow to dry and then place in garbage; for toxic pigments, use hazardous waste collection.
solvent-based	Recycle. Less than 1 pint: allow to evaporate with local exhaust ventilation or outside in a safe place, then place in garbage; for toxic pigments, use hazardous waste collection. More than 1 pint: hazardous waste collection.
pesticides	Hazardous waste collection. Containers, once completely empty, should be triple-rinsed and placed in garbage; rinse water can be used as pesticide.

PHOTOCHEMICALS

concentrates	Recycle or use hazardous waste collection.
solutions	Pour down sink, one at a time, with lots of water, if local regulations permit.
plastics resins	Recycle or use hazardous waste collection for large amounts. Smaller amounts can be reacted to form solid plastic.

SOLVENTS

liquid only	Less than 1 pint: evaporate in safe place. More than 1 pint: recycle or use hazardous waste collection. Chlorinated solvents (or mixtures containing them) should be collected separately from other solvents.
solid-containing	Let settle, filter, and recycle.

TABLE 25-1.
Source: Michael McCann. *Artist Beware* (Guilford, CT: The Lyons Press, 2005)
Reproduced by permission of the publisher.
See references for more information on spill control and disposal of art materials.

Twenty-six

FIRE PREVENTION

The storage and handling of flammable materials is regulated strictly by your local fire department. Art materials that are fire and explosion hazards include flammable and combustible solvents, organic dusts like rosin dust, cylinders of compressed gases for welding, and strong oxidizing agents like peroxide hardeners and potassium permanganate.

FLAMMABLE AND COMBUSTIBLE LIQUIDS

The flammability of a solvent is characterized by its flash point, the lowest temperature at which a liquid gives off enough vapors to form an ignitable mixture with air. If a source of ignition—flame, lit cigarette, spark, hot surface, or static electricity—is present, then a fire can result.

The lower flammable (or explosive) and upper flammable (or explosive) limits of a liquid are the minimum and maximum concentrations of liquid vapors in the air required for the liquid to catch fire if a source of ignition is present. Below the lower flammable limit, the mixture is too "lean" (not enough fuel), and above the upper flammable limit, the mixture is too "rich" (not enough oxygen).

The National Fire Protection Association (NFPA) classifies liquids as flammable if their flash point is under 100°F, and as combustible if their flash point is at or above 100°F. Flammable liquids can easily catch fire on a hot

day or even at room temperature if there is a source of ignition. The NFPA further classifies flammable liquids into Classes IA, IB, and IC, and combustible liquids into Classes II, IIIA, and IIIB. Table 26-1 shows the flammability classifications of many common solvents. Mixtures of solvents are often as flammable as the most flammable component since one component catching fire can then set off the others in the mixture. Heating a combustible liquid can convert it into a fire hazard since you might reach its flash point.

The Consumer Product Safety Commission (CPSC) uses a different classification system, defined by the Federal Hazardous Substances Act. According to the Act, a liquid is extremely flammable if its flash point is below 20°F, is flammable if its flash point is between 20°F and 80°F, and is combustible if its flash point is between 80°F and 150°F. The main difference between the two classification systems is that the NFPA defines liquids with flash points between 80°F and 100°F as flammable, whereas the CPSC defines them as combustible. The NFPA system is more protective since liquids with flash points between 80°F and 100°F could catch fire easily on a hot day.

Flammable liquids need particular care. More than one quart of solvent should be stored in an approved safety container. Large quantities of flammable and combustible liquids should be stored in capped flammable storage cabinets. Note that flammable storage cabinets are intended to prevent their contents from catching fire for at least ten minutes in order to allow room occupants time to escape. Waste solvents should be stored in solvent disposal containers, and solvent-soaked rags stored in proper oily waste disposal containers.

Purchase in as small a quantity as possible to limit the amount of flammable liquids present. Do not allow smoking in any studio containing flammable or combustible liquids. Eliminate all other sources of ignition such as flames, sparks, static electricity, hot metal surfaces, electric elements, etc. When pouring flammable liquids from large metal drums into metal containers connect them together with wire to ground them to prevent the buildup of static electricity, and ground the metal drum with a ground wire leading to a ground such as a tap or radiator. In areas in which large amounts of flammable liquids are used, all wiring and equipment should meet standards of the NFPA's National Electrical Code. Clean up spills of flammable liquids immediately.

NFPA FLAMMABILITY AND COMBUSTIBILITY DEFINITIONS

Flammable Liquids

CLASS IA Flash point: below 73°F (23°C) Boiling point: over 100°F (38°C)	Ethyl ether "Extremely flammable" aerosol sprays	
CLASS IB Flash point: below 73°F (23°C) Boiling point: over 100°F (38°C)	Acetone Benzine (VM&P naphtha) Benzol (benzene) Butyl acetate Cyclohexane Dioxane Ethyl acetate Ethyl alcohol	Ethylene dichloride Gasoline Heptane Hexane Isopropyl alcohol Methyl acetate Methyl alcohol Methyl ethyl ketone Toluene (toluol)
CLASS IC Flash point: 73–100°F (23–38°C) Boiling point: over 100°F (38°C)	Amyl acetate Amyl alcohol Butyl alcohol Methyl butyl ketone Methyl isobutyl ketone n-Propyl alcohol Styrene Trichloroethylene Turpentine Xylene (xylol)	

NFPA FLAMMABILITY AND COMBUSTIBILITY DEFINITIONS	
Combustible Liquids	
Class II Flash point: 100–140°F (38–60°C)	Cellosolve acetate Cyclohexanone Dimethyl formamide Ethyl silicate Isoamyl alcohol Kerosene Methyl cellosolve Mineral spirits (odorless paint thinner)
CLASS IIIA Flash point: 140–200°F (60–93°C)	Butyl cellosolve
CLASS IIIB Flash point: 200°F (93°C)	Cellosolve Diethylene glycol Ethylene glycol Hexylene glycol

Source: Michael McCann. *Artist Beware* (Guilford, CT: The Lyons Press, 2005)
Reproduced by permission of the publisher.

TABLE 26-1.

OTHER FIRE HAZARDS

Flammable and Combustible Solids: Many solids are combustible and can create fire or explosive hazards if proper precautions are not taken to prevent sparks, static electricity or other sources of ignition. Explosive hazards can result from dusts that can form explosive mixtures with air. Examples include: finely divided dusts of combustible solids such as carbon, rosin, wood, and plastics; and metal powders such as aluminum, zinc, magnesium, and iron. A lesser fire hazard is due to coarse dusts that may burn rapidly but do not form explosive mixtures with air. These include solid fibers and shredded materials such as cotton and hemp, which can create flash fires in the presence of an ignition source.

Precautions include eliminating sources of sparks, flames, lit cigarettes, and other sources of ignition, and carefully wet mopping or vacuuming explosive dusts and other combustible solids and storing them in approved self-closing, noncombustible waste cans. Only use vacuum cleaners approved for combustible dusts.

Spontaneous Combustion: Linseed oil, tung oil, and other organic oils slowly oxidize in air and release heat. Rags and paper towels soaked with these oils can spontaneously catch fire if the heat cannot dissipate and builds up. This is particularly a hazard when oily rags are placed in piles where the heat cannot dissipate.

Precautions include storing oil-soaked rags in approved oily waste cans that allow air to circulate around the can to dissipate heat. Do not put plastic liners in these containers since that will prevent the heat from dissipating. Empty daily. Alternatives are to hang the oily rags separately, or place them in a pail of water.

Oxidizing Agents: Oxidizing agents, or oxidizers, can react with organic solvents, combustible materials (e.g., wood dust, paper, cloth, etc.) and other organic materials to cause fires or explosions. Common examples of strong oxidizing agents are chlorates, dichromates, chromates, concentrated hydrogen peroxide, nitrates, and concentrated nitric acid. Organic peroxides, such as methyl ethyl ketone peroxide, can catch fire if heated.

Precautions include storing oxidizing agents away from solvents, paper, wood dust, and other combustible materials and other organic compounds.

Compressed Gases: Compressed flammable gases include acetylene and liquefied petroleum gases used in silver soldering and welding processes. Compressed oxygen cylinders are also a hazard, since, while oxygen itself is nonflammable, it supports combustion and can make combustible materials burn much more readily.

Store oxygen cylinders at least 20 feet from fuel cylinders or other flammable materials such as paints, solvents or oil, or separate by a 5-foot wall with a fire-resistance rating of at least a half hour. Do not store them near high traffic areas. Ventilate indoor storage areas. Keep cylinders away from all sources of sparks, electric arcs, open flames, direct sunlight, and other sources of heat. Secure all cylinders upright with chains or other fasteners.

Keep cylinders in carts designed for them. Transport these cylinders upright in carts. Ensure that grease or oil cannot come in contact with the cylinders, especially near the nozzle or valve, in order to protect against fire. You should always refer to manufacturers' operating manuals for compressed gases and regulators.

FIRE EXTINGUISHERS AND SPRINKLER SYSTEMS

Your studio should have the proper type of fire extinguisher. Class A fire extinguishers are good only for fire involving normal combustibles like paper and wood. Solvent or grease fires need Class B fire extinguishers, and electrical fires need Class C fire extinguishers. If you have all three types of fire hazards present, then you need a Class ABC multipurpose dry chemical fire extinguisher. If there is no Class A fire hazard, then a Class BC carbon dioxide fire extinguisher is adequate.

The fire extinguisher should be located near exits and near (but not too close) to major fire hazards. The fire extinguisher should be readily visible, and not obstructed in any way. You should have training in the use of your fire extinguisher.

Whenever possible, art studios should be equipped with water sprinkler systems. For school art studios, this is usually mandatory.

More detailed information on fire prevention can be found in the references in the bibliography. Information on where to get fire prevention equipment such as flammable storage cabinets, oily waste cans, fire extinguishers, etc. can be found in Appendix 2 at the end of the book.

PERSONAL PROTECTIVE EQUIPMENT

Personal protective equipment, especially respirators, should be considered a last resort after substitution, ventilation, and other protective measures have not worked. Personal protective equipment can be uncomfortable and not fit properly, interfere with communication, not provide complete protection, and only protect the person wearing it.

GLOVES

There are many different types of gloves for different purposes. For protection against high heat, use leather, woven fiberglass, or similar materials. Do not use asbestos gloves because studies have shown they can give off large amounts of asbestos fibers into the air.

For protection against liquids, there are a variety of rubber and plastic gloves. However, you have to match the glove to the liquid, since many liquids can penetrate different glove materials. Table 27-1 gives some recommendations for glove selection. Do not use natural rubber latex gloves since they can cause severe skin and respiratory allergies.

Most gloves do not provide good protection against chlorinated hydrocarbons and paint and varnish removers. The thicker the glove, of course, the better the protection. The life of a glove depends on a variety of conditions, including length of contact with the chemical, temperature, concentration of

liquid, and physical wear and tear. For example, your gloves will last longer when used with solvent-soaked rags than when used with pure liquid solvent solutions. You can also prolong the life of your gloves by washing them with soap and water before removing them and then allowing them to air dry. Cotton liners can help prevent dermatitis.

If gloves are not practical, then the use of barrier creams will provide some protection by placing an impermeable barrier between your skin and the chemicals. There are two basic types of barrier creams: water-insoluble and solvent-insoluble. These barrier creams have to be renewed several times a day.

GLOVE SELECTION	
Acids (dilute)	any type of rubber or plastic glove
Acids (concentrated)*	neoprene, butyl rubber, PVC**, nitrile,Viton***
Alkalis	any type of rubber or plastic glove
Alcohols	butyl, nitrile, or Viton
Aliphatic hydrocarbons (Petroleum distillates)	neoprene,nitrile, PVC, Viton
Aromatic hydrocarbons	Viton
Chlorinated hydrocarbons	nitrile or Viton
Glycol ethers	neoprene or nitrile
Ketones	butyl rubber
Turpentine	nitrile, Viton

TABLE 27-1.
* conc. Nitric acid: only use Viton
** PVC polyvinyl chloride
*** Viton is a registered trademark of DuPont Dow Elastomers

FACE AND EYE PROTECTION

The face and eyes must be protected against a variety of hazards, including impact (chipping, grinding, and so forth), radiation (such as infrared from kilns, glassblowing, welding, foundry; ultraviolet radiation from arc

welding, carbon arcs), and chemical splash (from acids, caustics, solvents and the like). Face shields are intended only to protect the face against damage; they do not provide adequate eye protection. Goggles should be worn under face shields. In most instances, only the eyes need protecting and goggles should be worn. All face and eye protection should meet the standards of the American National Standards Institute's Practice for Occupational and Educational Eye and Face Protection (ANSI Z87.1).

Protection against impact can involve use of spectacles with impact-resistant lenses and side shields, flexible or cushioned goggles, and chipping or eyecup goggles. Spectacles without side shields are the least useful. Goggles are available that can be worn with glasses, and goggles can be obtained with prescription lenses.

Protection against infrared radiation required infrared goggles or goggles with shade ratings between 2 and 3. Various welding goggles with different shade numbers are available, depending on the intensity of the ultraviolet radiation. For arc welding, face shields are also needed.

Protection against chemical splash depends on the severity of the potential exposure. For working with hot, concentrated acids, either face shields with goggles or complete hoods covering the head and shoulders are available. For other situations, chemical goggles with baffled ventilation are available. If the gases are eye irritants, you might need unvented goggles that will not let the eye irritants enter the goggles.

HEARING PROTECTORS

Excessive noise over a period of years can cause hearing loss. In addition, heart disease, gastrointestinal disorders, allergies, and similar ailments have been linked to excessive noise. A rule of thumb is that if you have to raise your voice to be heard one to two feet away, then you have a noise hazard.

Noise levels are measured in decibels (dB) on the logarithmic scale; every increase of 10 dB means the noise intensity has increased tenfold. Table 27-2 lists the noise levels of some common activities.

The Occupational Safety and Health Administration (OSHA) has set a maximum permissible noise level of 90 dB for an eight-hour day and a ceiling of 115 dB. Even this level, however, could cause hearing loss in about 20 percent of the population.

If noise-control measures such as isolation, proper maintenance, silencers, mufflers, vibration isolators (shock absorbers), or quieter machines are not practical or do not work, then you will have to wear ear plugs or ear muffs. Ear plugs come in a variety of sizes and types. Some of the new foam ear plugs are almost as good as ear muffs. The use of improvised materials like wax or cotton is not recommended; they may themselves be harmful.

NOISE LEVELS OF COMMON ACTIVITIES	
dance club	115 dB
woodshop	110 dB
circular saw	100–109 dB
foundry	90–99 dB
machine shop	80–89 dB
spraying	80–89 dB
ordinary conversation	60 dB

TABLE 27-2.

RESPIRATORS

The Occupational Safety and Health Act of 1970 states that respirators are allowed only for emergency use, when engineering controls (e.g., ventilation) are not feasible, or as a temporary measure while engineering controls are installed. Further, OSHA requires a written respirator program if respirators are used. This respirator program includes information on such matters as respirator selection, fit testing, cleaning, storage, and inspection. It also requires a medical examination for anyone wearing a respirator because the extra breathing strain caused by respirator resistance to air can be hazardous to people with certain heart, lung, and other problems. These same rules are useful for anyone wearing a respirator.

Respirators come in two basic types: air-supplying and air-purifying. Air-supplying respirators provide a source of uncontaminated air for a person to breathe. The air can come from a self-contained breathing apparatus

(SCBA), from separate tanks of breathable compressed air, or from an air compressor. This type of respirator is expensive, and requires considerable training in safe use. It is needed only in cases of oxygen deficiency or with chemicals that are immediately harmful to life or health. Artists should carefully review their materials and processes and consider substitution or ventilation before considering air-supplying respirators.

Air-purifying respirators, on the other hand, remove the toxic chemicals from the air you are breathing. The air-purifying respirator consists of two basic parts, the facepiece, and the cartridge, canister, or filter that removes the contaminant. The facepiece can be full face, giving the eyes protection against eye irritants; half face, which covers mouth, nose and chin; or quarter face, which only covers the mouth and nose. Nowadays, respirator facepieces often come in several sizes and will fit women and others with small faces. In addition, there are disposable respirators that combine the filter and facepiece. These do not provide as much protection as the standard type.

Different cartridges and filters are available to remove different contaminants. Filters to remove particulates can be for dusts and mists to remove dusts and particulate mists, or for dusts, mists, and fumes to remove welding metal fumes. High-efficiency filters are also available for radioactive dusts, and extremely toxic dusts such as asbestos, lead, and cadmium. You replace the filters when they become difficult to breathe through.

The National Institute for Occupational Safety and Health (NIOSH) approves respirators. For particulate respirators, NIOSH has established nine classes of filters: three levels of filter efficiency, each with three categories of filter resistance to oil. The three levels of filter efficiency are 95%, 99%, and 99.97%. The three categories of resistance to filter efficiency degradation are labeled N (not resistant to oil), R (resistant to oil for a limited time), and P (oil-proof). N100 dust respirators should be used with cancer-causing agents like silica.

There are three basic types of cartridges: organic vapor, ammonia; and acid gas. Combinations of different types of cartridges (and of cartridges and filters) are also available. See Table 27-3 for selection of respirator cartridges and filters.

SELECTION OF RESPIRATOR CARTRIDGES AND/OR FILTERS

Substances or Process	Cartridge	Filter
Acid gases (except nitric acid)	AG	—
Acid mists	AG	N95
Aerosol spray cans	OV	N95
Air brush		
water-based	—	N95
solvent-based	OV	N95
cadmium, chromium (VI) pigments		N100, HEPA
Ammonia	A	—
Asbestos (low levels only)	—	N100, HEPA*
Chlorine gas	AG	—
Clay, glaze powders	—	N100
Dye powders	—	N95
Enamel powders	—	N95
Fiberglass dust	—	N95
Formaldehyde	OV	—
Hydrofluoric acid	AG	—
Hydrogen chloride gas	AG	—
Lacquers	OV	—
Lead-containing powders/fumes		N99, N100, HEPA
Metal fumes (casting, welding)	—	N95
Lead, cadmium nickel		N100, HEPA
Metal grinding		
Oil-based lubricant		R95, P95
Water-based/no lubricant		N95
Metal powders	—	N95
Oil mists		P95, R95
Paint strippers (solvent type)	OV	—

Substances or Process	Cartridge	Filter
Pastel dusts	—	N95
Pigment powders	—	N95
Plastic resins and glues	OV	—
Plastics sanding, grinding	—	N95
polyvinyl chloride	AG	N95
polyurethane	OV	N95
formaldehyde plastics	OV	N95
Silica		N100, HEPA
Soldering, lead		
Acid fluxes	AG	N100, HEPA
Organic fluxes	OV	N100, HEPA
Soldering, hard (cadmium-free)		
Fluoride fluxes	AG	N95
Borax fluxes		N95
Solvents	OV	—
Spraying		
water-based	—	N95
solvent-based	OV	N95
polyurethane foam resins	SA**	—
Sulfur dioxide	AG	—
Welding See metal fumes		

TABLE 27-3.
*Supplied-air recommended for high levels of asbestos dust.
** Supplied air respirator
Source: Michael McCann. *Artist Beware* (Guilford, CT: The Lyons Press, 2005)
Reproduced by permission of the publisher.

Since the purifying chemicals in cartridges get used up, eventually the vapors or gases start to pass through the cartridge. The time this takes depends on the frequency and length of exposure, and on the concentration of the contaminant.

A general rule of thumb is that cartridges should be changed after 10 days, after eight hours of cumulative use, or if the contaminant can be smelled. For

this reason, you should not use a respirator with chemicals that have poor odor warning. These include methyl alcohol, nitrogen dioxide (from acid etching), isocyanates from polyurethane resins, and carbon monoxide.

In choosing a respirator there are several important factors to take into account. First, the respirator must be approved by the National Institute for Occupational Safety and Health (NIOSH). Do not use "nuisance dust" or "non-toxic dust" masks for protection against toxic materials. Second, make sure the respirator fits properly and comfortably. If it doesn't, air will take the path of least resistance and leak in around the edges. People with beards, unusually shaped faces, scars, and the like will not be able to get an adequate fit. Eyeglasses can sometimes interfere with a good fit, although a change in frame style can help. Fit testing should be done before you wear a respirator. Qualitative fit testing involves exposing the respirator wearer to an agent which can be detected by irritation, odor or taste (e.g., isoamyl acetate (banana oil), irritant smoke, saccharin mist, or Bitrex).

To make a simple negative-pressure fit test, block the air inlets, inhale, and hold your breath about 20 seconds. The respirator facepiece should collapse around your face due to the negative pressure inside the respirator. If it does not collapse or goes back to normal, your facepiece does not fit. Try another model and make until you find one that does. This test should be done every time you put on the respirator.

The following is a protocol for qualitative fit testing with negative and positive pressure tests with isoamyl acetate:

1. Check first with a small concentration of isoamyl acetate to make sure you can detect the odor of banana oil. If you cannot detect the odor of banana oil, repeat the steps below with irritant smoke tubes and N95 dust filters. Be sure to close your eyes when doing this test.
2. Put on the respirator and adjust the straps to get a comfortable fit.
3. Carry out a negative pressure test to see if the fit is approximate.
4. Carry out a positive pressure test if possible.
5. If you do not pass either the negative or positive pressure test, go to step 9.

6. Wear the respirator for a while in a clean atmosphere to get used to it.

7. Saturate a sponge or piece of fabric with isoamyl acetate and then move it around the face-piece seal. An improved version of this test involves using a hood (e.g., the plastic lining of a 55-gallon drum on a wire frame) and placing the saturated fabric or sponge inside the hood.

 It is important to keep individuals to be tested isolated from the isoamyl acetate-contaminated environment, since olfactory fatigue can reduce the ability to detect the isoamyl acetate odor over time.

8. Perform the following exercises for two minutes: (a) normal breathing, (b) deep breathing (five breaths), (c) moving head up and down, (d) moving head from side to side, (e) talking, and (f) normal breathing. If you can detect the odor of the banana oil, then the respirator fails the test.

9. If your respirator fails either the positive or negative pressure test, or the isoamyl acetate test, then you should first readjust the position of the face piece and adjust the straps to get a comfortable yet secure fit. Then retry the fit test. If you still cannot get a fit, try another model or size.

This test can also be used to determine if your organic vapor cartridge is used up and as a regular checkup to determine if your respirator has been damaged and no longer gives a good fit.

Respirators should be regularly checked for damage and cleaned (and disinfected if more than one person uses it—a practice we do not recommend). One recommended cleaning procedure consists of (1) removing cartridges and filters, (2) washing the facepiece and any tubing with soap and water using a handbrush, (3) rinsing completely in warm water, (4) air-drying in a clean area, (5) cleaning other parts as recommended by the manufacturer, and (6) inspecting the respirator for damage. After this is completed, the respirator should be reassembled and stored in a plastic bag or container away from chemicals, dust, light, moisture and heat.

See *Art Safety Procedures: A Health and Safety Manual* for Art Schools and Art Departments for more information on respirators, including fit testing protocols. It is available online at www.uic.edu/sph/glakes/harts.

OTHER PROTECTIVE CLOTHING AND EQUIPMENT

A wide variety of personal protective clothing and equipment is available besides that discussed so far. These include leather aprons or clothing for heat protection, protective leggings and sleeves, hard hats, safety shoes, hair nets, and others. You should obtain a safety-supply catalog from a safety-equipment distributor to discover what is available. See Appendix 2 at the end of the book for a list of safety supply distributors.

Twenty-eight

ART STUDENT SAFETY

Art involves a lot of experimentation and use of hazardous materials, which can often create the potential for health and safety problems. In an art class, this can put other students and staff at risk in addition to yourself. A class of students using hazardous materials creates a much greater risk than just one person using art materials due to the larger amounts being used. Therefore, standard safety procedures are needed in art schools and art departments to protect people.

The following are some procedures which your art department should institute and which you should follow:

1. Art students should purchase art materials from a school supply store or from an approved list. Material Safety Data Sheets should be obtained on all art materials and you should read them.
2. There should be a formal approval mechanism before a student or art teacher can bring a new art material or art process into a studio. The material or process should be evaluated to determine if it can be used safely in that room.
3. Your school should have a procedure for determining who can work unsupervised. This should be determined by level of training, including safety training.

4. Never work alone. Use the buddy system. Always make sure some-one outside (e.g., security guard) knows where you are in case of an emergency. There should be a sign in and sign out procedure.

5. Make sure there are adequate precautions for the art materials you are using. This includes adequate ventilation, eyewash fountains, emergency showers (where needed), first aid kit, fire extinguisher, etc.

6. Wear the appropriate specific personal protective equipment. This can include gloves, goggles, face shield, protective clothing, and respirators. Remember, you should be medically approved and fit tested to wear a respirator.

7. Where local exhaust ventilation is provided for a particular process, only work in that area.

8. Do not store solvents or other flammable materials in lockers.

9. Know the exit routes from the studio in case of fire or other emergency.

10. If a fire or spill occurs in your studio, know the proper procedure to report it. There should be an emergency telephone or intercom in the studio. Do not try to fight a fire or clean up a hazardous spill unless you are trained to do so.

11. If you are injured or exposed to a hazardous chemical (for example, a splash of acid or solvent in the eyes), follow the emergency procedures (rinse your eyes out with the eyewash and then seek medical help). Report all incidents.

12. Malfunctioning equipment (machinery, ventilation systems, respirators, etc.) should be immediately reported.

13. Obey any safety rules established by the school.

Twenty-nine

HOW TO GET HELP

MEDICAL HELP

If you are having symptoms that only appear when you are working or a few hours later, and tend to dissipate when you are away from work for several days, then they might be related to overexposure to your art materials. The illness might be caused directly by the art materials, or the art materials may be exacerbating a medical problem you already have. In either case you should see a doctor.

You should tell your doctor what materials you are working with and any information you have about the effects of these chemicals. Sometimes you can help pinpoint the specific chemical causing a problem by keeping a log of what materials you are using when the symptoms appear.

One problem may be finding a doctor who is knowledgeable about the toxic effects of chemicals or who will listen to you when you say your symptoms may be caused by exposure to your art materials. Most physicians have no training in the toxic effects of chemicals and even fewer are knowledgeable about art materials. If your physician will not listen to you, find one who will.

Often you may need a referral to a physician who is an expert in occupational medicine. Appendix 1 is a list of occupational health clinics around the United States and Canada that have physicians with this expertise.

Even if you are not having symptoms, you might want to have a checkup to see if your art materials are harming you. Most medical-surveillance tests check for damage to body organs and do not test for the presence of chemicals. The major exception is lead, and anyone exposed to lead should have regular blood lead tests. Other common medical-surveillance tests include lung-function tests and sometimes chest x-rays if you are exposed to dusts or respiratory irritants, liver- and kidney-function tests if you are exposed to solvents and other chemicals affecting these organs, and audiograms if you are exposed to excessive noise. In many instances, you should get a baseline test now, and then repeat the test every few years to see if there is any change.

SOURCES OF SAFETY EQUIPMENT

Appendix 2 lists suppliers of respirators and other safety equipment. Most major cities have distributors of safety equipment. You should check the Yellow Pages under safety equipment for the nearest one.

FOR FURTHER INFORMATION

The Great Lakes Centers for Occupational and Environmental Safety and Health at the University of Illinois at Chicago has a Health in the Arts Program. Many of the publications developed by the Center for Safety in the Arts are available on the web site at the following address: www.uic.edu/sph/glakes/harts.

The Chicago Artists Resource is a non-profit that has a section on art hazards with many of the Center for Safety in the Arts publications, including articles from the Art Hazards News. It is available at: http://www.chicagoartistsresource.org/?q=section/737/751.

The non-profit organization ACTS (Arts, Crafts, and Theater Safety) provides a newsletter, publications and answers art hazards inquiries. Run by Monona Rossol, it is available at: http://www.artscraftstheatersafety.org/.

Other possible sources of help on art hazards are your local American Lung Association, regional offices of the National Institute for Occupational Safety and Health (NIOSH) and, in Canada, the Canadian Center for Occupational Health and Safety in Hamilton.

The bibliography lists general references on occupational health and specific references on art hazards.

OCCUPATIONAL HEALTH CLINICS—2007

This list was provided by the Association of Occupational and Environmental Health Clinics.

CALIFORNIA

University of California-Davis
 Medical Center
Occupational and Environmental
 Health Clinic
Employee Health Service
Cypress Building Suite A
2221 Stockton Blvd.
Sacramento, CA 95817
Clinic appts. (530) 754-7635

University of California-
 San Francisco
Occupational and Environmental
 Health Clinic
2380 Sutter Street, 3rd Floor.
San Francisco, CA 94115
Clinic appts. (415) 885-7580

University of California-Irvine
Occupational and Environmental
 Health Clinic
5201 California Avenue, Suite 100
Irvine, CA 92617
Phone: 949-824-8641

COLORADO

Medical Occupational &
 Environmental Toxicology
10099 RidgeGate Parkway, Suite 220
Lone Tree, CO 80124
Phone: (303) 815-1960

National Jewish Medical
 Research Center
Division of Environmental and Occu-
 pational Health Sciences
1400 Jackson Street
Denver, CO 80206
Clinic appts: (303) 398-1733

Denver Health Center for
 Occupational Safety and Health
605 Bannock Street, Unit 3, Room 462
Denver, CO 80204-4507
303-436-7155

Second site: Denver Health Clinic at
 DIA Airport
Main Terminal – 6th Level
8400 Pena Blvd.
Denver, CO 80249
303-317-0607

CONNECTICUT

University of Connecticut-
 Farmington
Occupational and Environmental
 Medicine Program
263 Farmington Ave.
Farmington, CT 06030-6210
Phone: (860) 679-2893

Yale University Occupational/
 Environmental Medicine Program
135 College Street, 3rd Floor
New Haven, CT 06510
http://info.med.yale.edu/intmed/
 yoemp
Phone: (203) 785-6434

DISTRICT OF COLUMBIA

George Washington University
 Environmental and Occupational
 Health
Division of Occupational Medicine
 and Toxicology
Department of Medicine
School of Medicine and Health
 Services
2100 M Street NW, Suite 203
Washington, DC 20052
Phone: 202-994-1734

FLORIDA

Comprehensive Occupational
 Medicine for Business and
 Industry (COMBI)
9210 Florida Palm Drive
Tampa, FL 33619
Phone: (813) 246-4277

GEORGIA

The Georgia Occupational and
 Environmental Toxicology Clinic
Grady Memorial Hospital
80 Jesse Hill Jr. Drive
12th Floor, C Wing
Atlanta, GA 30303
Phone: 404-616-4403

Georgia Poison Center
Clinic: 404-616-4592

ILLINOIS

John H Stroger, Jr. Hospital of Cook
 County
Occupational and Environmental
 Medicine
1900 W. Polk, Rm. 500
Chicago, IL 60612
Phone: (312) 864-5520

University of Illinois - Chicago
Occupational Medicine Program
835 S. Wolcott M/C 684
Chicago, IL 60612
Phone: (312) 864-5520

IOWA

University of Iowa Department of
 Internal Medicine
Occupational Medicine Clinic
200 Hawkins Drive
Iowa City, IA 52242
Clinic appts: (319) 356-8486

KANSAS

The University of Kansas Medical
Center
Center for Environmental & Occupa-
tional Health
3901 Rainbow Blvd., G572 KU
Hospital
Kansas City, KS 66160-7371
Phone: (913) 588-7146

KENTUCKY

University of Kentucky
Occupational Medicine Program
2400 Greatstone Point
Lexington, KY 40504
Phone: (859) 257-5150

MARYLAND

Johns Hopkins University
Center for Occupational and
Environmental Health
5501 Hopkins Bayview Circle
Baltimore, MD 21224
Phone: (410) 955-4355

University of Maryland School of
Medicine
Occupational Health Program
Division of General Internal Medicine
405 West Redwood Street
Baltimore, MD 21201
Phone: (410) 706-7464

MASSACHUSETTS

Caritas Good Samaritan
Occupational Health Services
75 Stockwell Drive, Merchants
Building
Avon, MA 02322
Phone: (508) 427-3900

Boston University
Occupational Health Center
930 Commonwealth Avenue, West
Boston, MA 02115
Phone: (617) 353-6630

Cambridge Hospital
Occupational & Environmental
Health Center
1493 Cambridge Street
Cambridge, MA 02139
Phone: (617) 665-1580

Kindred Hospital Northeast
Braintree Hospital
Center for Occupational and
Environmental Medicine
2001 Washington Street
South Braintree, MA 02184
Clinic appts: (781) 952-2400

Children's Hospital
Pediatric Environmental Health
Center
300 Longwood Avenue, 5th Floor
Boston, MA 02115
Phone: (617) 355-8177

The CareGroup Occupational
Health Network
70 Parker Hill Avenue
Boston, MA 02120
Phone: (617) 754-6780
www.occhealth.caregroup.org

• New England Baptist Hospital
 Occupational Medicine Center
 125 Parker Hill Ave
 Boston, MA 02120
 Phone: (617) 754-5620

- The Occupational Health Center of Waltham
840 Winter Street Waltham, MA 02451
Phone: (781) 684-0404

- The Occupational Health Center of Chelsea
1000 Broadway Chelsea, MA 02150
Phone: (617) 660-6360

- The Occupational Health Center of Stoneham
61 Main Street Stoneham, MA 02180
Phone: (781) 438-9600

- Mount Auburn Hospital Occupational Health Services & Mount Auburn Hospital Employee Assistance Program
777 Concord Ave, Suite 301
Cambridge, MA 02138
Phone: (617) 354-0546

- The Occupational Health Center at Nashoba Valley Regional Medical Center
200 Groton Road Ayer, MA 01432
Phone: (978) 784-9328

- Milton Hospital Occupational Health Services
92 Highland Ave Milton, MA 02186
Phone: (617) 696-4600 x1681

- The Occupational Health Center at Fogarty
1st Floor of the Rehabilitation Hospital of Rhode Island
116 Eddie Dowling Highway N. Smithfield, RI 02896
Phone: (401) 769-2200 x5400

MICHIGAN

Center for Occupational and Environmental Medicine, P.C.
118 North Washington Avenue
Royal Oak, MI 48067
Phone: 248-547-9100

Wayne State University Department of Family Medicine
Division of Occupational and Environmental Medicine
15400 W. McNichols, 2nd Floor
Detroit, MI 48235
Phone: (313) 340-4305

Michigan State University Department of Medicine
117 West Fee
East Lansing, MI 48824-1316
Clinic appts: (517) 353-4941

Mid Michigan Physicians
1200 East Michigan, Suite 460
Lansing, MI 48912
Phone: 517-487-8200

MINNESOTA

HealthPartners-Regions Hospital (St. Paul Site)
Occupational and Environmental Medicine

205 South Wabasha Street
St. Paul, MN 55107
Phone: 651-293-8104

Occupational and Environmental
 Medicine (Minneapolis Site)
HealthPartners Riverside Clinic
2220 Riverside Avenue South
Minneapolis, MN 55454
paula.a.geiger@healthpartners.com
Heidi.K.RoeberRice@HealthPartners.
 com

MONTANA
St. Patrick Hospital and Health
 Sciences Center
Occupational Health Services
3075 North Reserve Street
Missoula, MT 59808
Phone: 406-329-5746

NEW MEXICO
Presbyterian Occupational
 Medicine Clinic
P.O. Box 26666
Albuquerque, NM
 87125-6666
Phone: (505) 823-8450

University of New Mexico
Occupational and Environmental
 Medicine Clinic
4808 McMahon NW
Albuquerque, NM 87114
Clinic appts: (505) 272-2900

NEW YORK
Central New York Occupational
 Health Clinical Center
6712 Brooklawn Parkway, Suite 204

Syracuse, NY 13211-2195
Phone: (315) 432-8899

University of Stony Brook School of
 Medicine
Center for Occupational and
 Environmental Medicine
Health Sciences Center, L 3-086
University at Stony Brook
 Stony Brook, NY 11794
Phone: (631) 444-2196

Occupational and Environmental
 Health Center of Eastern New York
1873 Western Avenue
Albany, NY 12203
Phone: (518) 690-4420

Mount Sinai-Irving J. Selikoff Center
Center for Occupational and
 Environmental Medicine
1391 Madison Avenue
One Gustave L. Levy Place
New York, NY 10029
Clinic appts: 212-987-6043

• Manhattan Center
 1200 Fifth Avenue 1st Floor
 New York, NY 10029
 Phone: (212) 241-5059

• Queens Division
 25-35 30th Road
 Astoria, NY 11102
 Phone: (718) 278-2736

• Hudson Valley Division
 Located at St. John's Riverside
 Hospital
 967 North Broadway, Level S1
 Yonkers, NY 10701
 Phone: (914) 964-4737

New York University-Bellevue
Occupational and Environmental
 Medicine Clinic
Bellevue Hospital, Room CD349
462 First Avenue
New York, NY 10016
Phone: (212) 562-4572

Finger Lakes Occupational Health
 Services
2180 South Clinton Avenue, Suite D
Rochester, NY 14618
Phone: (585) 274-4554

Comprehensive Occupational
 Medical Services
51 Webster Street
North Tonawanda, NY 14120
Phone: (716) 692-6541

NEW JERSEY
UMDNJ - Robert Wood Johnson
 Medical School
Clinical Center for Occupational and
 Environmental Health
Environmental and Occupational
 Health Sciences Institute
170 Frelinghuysen Road
Piscataway, NJ 08854
Phone: (732) 445-0123

NORTH CAROLINA
Duke University Medical Center
Division of Occupational and
 Environmental Medicine
Box 3834
Durham, NC 27710
Phone: (919) 286-3232

OHIO
Case Western Reserve University
MaryAnn Swettland Center for
 Environmental Health
1900 Euclid Ave. Wood Bldg. WG 19
 Cleveland, OH 44106
Phone: 216-368-5967

University of Cincinnati
Center for Occupational Medicine
Medical Arts Bldg., 3rd Floor
3223 Eden Avenue, ML #0458.
Cincinnati, OH 45267-0458
Phone: (513) 558-1234

PENNSYLVANIA
University of Pittsburgh Graduate
 School of Public Health
Occupational and Environmental
 Medicine Program
130 DeSoto Street
 Pittsburgh, PA 15261
Phone: (412) 624-9985

University of Pennsylvania School
 of Medicine
Occupational Medicine
Silverstein Pavilion,
3400 Spruce Street
Philadelphia, PA 19104-4283
Clinic appts: (215) 662-2354

Consulting Toxicologists, LLC
110 West Lancaster Avenue, Suite 230
Wayne, PA 19087
Clinic appts: (610) 688-6700

RHODE ISLAND

Occupational and Environmental
 Health Center of Rhode Island
410 South Main Street
Providence, RI 02903
Phone: (401) 621-2228

TEXAS

University of Texas Health Center
 at Tyler
11937 US Highway 271
Tyler, TX 75708-3154
www.tiosh.org
Phone: (903) 877-5609

University of Texas Health Services
7000 Fannin, Suite 1620
Houston, TX 77030
Phone: (713) 500-3267

UTAH

University of Utah Family and
 Preventive Medicine
Rocky Mountain Center for Occupa-
 tional and Environmental Health
75 South 2000 East (Administration
 Offices)
Salt Lake City, UT 84112-0512
Clinic appts: 801-581-5056

VIRGINIA

Carilion Roanoke Community
 Hospital
Carilion Occupational Medicine
101 Elm Avenue
Roanoke, VA 24013
Clinic Phone: 540-985-8521

WASHINGTON

University of Washington Harbor-
 view Medical Center
Occupational and Environmental
 Medicine Program
325 Ninth Ave. #359739
Seattle, WA 98104-2499
Phone: 206-744-9381

WEST VIRGINIA

Division of Occupational &
 Environmental Health
Dept. of Family & Community
 Medicine
Marshall University School of
 Medicine
1600 Medical Center
Huntington, WV 25701
Phone: (304) 691-1178

West Virginia University School of
 Medicine
Institute of Occupational and
 Environmental Health
3801 Robert F. Byrd Health Science
 Center South
Morgantown, WV 26506-9190
Phone: 304-293-3693

CANADA

ALBERTA

University of Alberta Department
of Public Health Sciences
Occupational Medicine Clinic
13-103 Clinical Sciences Building
Edmonton, AB T6G 2G3
Phone: 780-492-6291
Nicola.cherry@ualberta.ca

MANITOBA

UMFL Occupational Health
Centre, Inc.
102-275 Broadway
Winnipeg, MB, CD R3C 4M6
http://www.mflohc.mb.ca
Phone: (204) 926-7900

ONTARIO

Occupational Health Clinics for
Ontario Workers-Toronto
970 Lawrence Avenue West, Suite 110
Toronto, ON M6A 3B6
CANADA
Phone: (888) 596-3800 x 228

Occupational Health Clinics for
Ontario Workers, Hamilton
848 Main Street
Hamilton, ON L8M 1L9
CANADA
Clinic Phone: (905) 549-2552;
800-263-2129

Occupational Health Clinics for
Ontario Workers, Sudbury
1300 Paris Street, Suite 4
Sudbury, ON P3E 3A3
CANADA
Phone: (416) 443-7669

Occupational Health Clinics for
Ontario Workers, Windsor
3129 Marentette Avenue, Unit 1
Windsor, ON N8X- 4G1
CANADA
Phone: (800) 565-3185

Occupational Health Clinics for
Ontario Workers, Point Edward/
Sarnia
171 Kendall St.
Point Edward, ON N7V 4G6
CANADA
Jim Brophy, Executive Director
Clinic Phone: (519) 337-4627

QUEBEC
Clinique Interuniversitaire de Sante
 au Travail et da Sante Environ-
 nementale (CISTE) /
Inter-university Occupational and
 Environmental Health Clinic
Clinique ambulatoire de l'Instutut
 Thoracique de Montreal
Montreal Chest Institute Ambulatory
 Clinic
3666 St-Urbain
Montreal, QC
CANADA H2X 2P4
Phone: (514) 934-1934 x32622

SAFETY SUPPLY SOURCES—2007

The following lists large, full-line distributors of safety equipment.

Mobile, AL
Fisher Safety Company
www.fishersafety.com
(334) 661–2338

Anchorage, AK
Alaska Safety, Inc.
www.alaskasafety.com
(907) 561–5661

Little Rock, AR
Medsafe
www.gosafe.com
(501) 227–5513

Tempe, AZ
Direct Safety Company
www.directsafety.com
(800)528–7405

Oakland, CA
Industrial Safety Supply
 Corporation
www.issc.com
(510) 658–0414

Stockton, CA
Delta Safety Supply
www.deltasafety.com
(209) 466–9866

Empire, CO
DXP/Safety Master
www.dxpe.com
(303) 271–0107

W. Hartford, CT
Industrial Safety & Supply
www.industrialsafety.com
(800) 243–2316

Wilmington, DE
McDonald Safety Equipment Inc.
www.mcdonaldsafety.com
(302) 999–0151

Orlando, FL
Fisher Safety Company
www.fishersafety.com
(407) 678–2701

Tampa, FL
Northern SAFECO, Inc.
www.safecoinc.com
(813) 754-7271

Atlanta, GA
Fisher Safety Company
www.fishersafety.com
(770) 446–8509

Waipahu, HI
Guy Miyashiro and Co., Inc.
(808) 678–0287

Davenport, IA
S. J. Smith Co., Inc.
www.sjsmith.com
(319) 324–5237

Boise, ID
NORCO
www.norco–inc.com
(800) 574–5885

Chicago, IL
Magid Glove & Safety Mfg. Co.
www.magidglove.com
(773) 384–2070

Northbrook, IL
Saf-T-Gard International, Inc.
www.saftgard.com
(847) 291–1600

Schererville, IN
Great Lakes Safety & Supply
www.greatlakessafety.com
(800) 499–5253

Wichita, KS
Mid-Continent Safety, LLC
www.midsafe.com
(316) 522–0900

Louisville, KY
Orr Safety Corp.
www.orrcorp.com
(502) 774–5791

Gonzales, LA
Southland Fire & Safety
Equipment, Inc
www.southlandfire.com
(225) 621–3473

Sturbridge, MA
Safety Source-Northeast
www.safetysourcenortheast.com
(508) 248–4265

Landover, MD
Metropolitan Safety, Inc
www.metropolitansafety.com
(301) 772–1717

Gray, ME
Hagemeyer
(207) 657–5011

Kalamazoo, MI
Safety Services, Inc.
www.safetyservicesinc.com
(616) 382–1052

Eagan, MN
Continental Safety Equipment
www.csesafety.com
(800) 844-7003

St. Louis, MO
Orr Safety Corporation
www.orrcorp.com
(314) 343–0158

Pascagoula, MS
Dolphin Safety Supply, Inc.
(800) 769-2163

Billings, MT
DXP/Safety Master
www.dxpe.com
(406) 248–8098

Raleigh, NC
SAFECO, Inc.
www.safecoinc.com
(919) 231–3232

Fremont, NE
Dunrite, Inc.
www.dunriteinc.com
(800) 782-3061

Marlborough, NH
Safety Environmental
Control
(888) 357–9760

Elmwood Park, NJ
The Olympic Glove & Safety
Company, Inc
www.ogs-inc.com
(800) 526–0122

Farmington, NM
DXP/Safety Master
www.dxpe.com
(505) 326–3333

Sparks, NV
Interstate Safety
www.interstatesafety.net
(775) 355–2000

Utica, NY
Northern Safety Co., Inc.
www.northernsafety.com
(315) 793–4900

Maspeth, NY
AWISCO NY Corp.
www.awisco.com
(800) 834-1925

Cleveland, OH
Industrial Safety Products, Inc.
www.indsaf.com
(216) 524–0360

Tulsa, OK
Medsafe
www.gosafe.com
(918) 622–8128

Redwood, OR
NORCO
www.norco-inc.com
(208) 336-1643

Pittsburgh, PA
Fisher Safety Company
www.fishersafety.com
(412) 490–8780

San Juan, PR
Fisher Safety Company
www.fishersafety.com
(800) 237-6705

Greenwich, SC
SAFECO, Inc.
www.safecoinc.com
(864) 877-9700

Kingsport, TN
Northern SAFECO, Inc.
www.safecoinc.com
(800) 635-6330

Corpus Christi, TX
DXP/Safety Master
www.dxpe.com
(713) 996–6071

Marshall, TX
Medsafe
www.gosafe.com
(903) 935-1811

Salt Lake City, UT
Industrial Supply Co.
http://www.indsupply.com
(801) 484–8644

Richmond, VA
SAFECO, Inc.
www.safecoinc.com
(804) 222–9100

Everett, WA
Sound Safety Products, Inc
www.soundsafetyproducts.com
(425) 259–0026

Janesville, WI
Lab Safety Supply, Inc.
www.labsafety.com
(608) 757–4636

Charleston, WV
Orr Safety Corporation
www.orrcorp.com
(304) 755–4800

Casper, WY
DXP/Safety Master
www.dxpe.com
(307) 266–2140

CANADIAN SAFETY EQUIPMENT DISTRIBUTORS

Acklands-Grainger Inc.
www.acklandsgrainger.com
(800) 265–9135
Has over 200 sales offices across
 Canada.

BIBLIOGRAPHY

ART HAZARDS REFERENCES

1. Agoston, G. (1969). Health and safety hazards of art materials. *Leonardo* 2, 373.
2. Alexander, W. (1973/74). Ceramic toxicology. *Studio Potter*. Winter, 35.
3. American Art Clay Co., Inc. (1987). *Ceramics Art Material Safety in the Classroom and Studio*. AMACO, Indianapolis, IN.
4. American National Standards Institute (ANSI). 2000a. *American National Standard for the Safe Use of Lasers, ANSI Z136.1-2000.* Laser Institute of America, Orlando.
5. American National Standards Institute (ANSI). 2000b. *American National Standard for the Safe Use of Lasers in Educational Institutions, ANSI Z136.5-2000.* Laser Institute of America, Orlando.
6. Arts, Crafts and Theater Safety. Acts Facts. newsletter.
7. ASTM Subcommittee D01.57 on Artist Paints and Related Materials. (1984). ASTM D4236. *Standard Practice for Labeling Art Materials for Chronic Health Problems.* American Society for Testing and Materials, Philadelphia, PA.
8. Ayers, G., and Zaczkowski, J. (1991). *Photo Developments B A Guide to Handling Photographic Chemicals.* Envision Compliance Ltd., Bramalea, Ont., Canada.
9. Babin, A. and McCann, M. (1992). *Waste Management and Disposal for Artists and Schools.* Center for Safety in the Arts, New York, NY.
10. Bailey, J. R. (1977). What evil lurks? *Photomethods Magazine.* 20(2), 51.
11. Ballesteros, M., Zuniga, C. M. A., Cardenas, 0. A. (1983). Lead concentrations in the blood of children from pottery-making families exposed to lead salts in a Mexican village. *Bull. Pan. Am. Health Org.* 17(1), 35–41.
12. Barazani, G. (1974 to 1981). Protecting your health, column. *Working Craftsman* (and the *Crafts Report*).

13. ———. (Ed.). (1977). *Health Hazards in Art Newsletter* I & II. Hazards in Art, Chicago, IL.

14. ———. (1978). *Safe Practices in the Arts and Crafts: A Studio Guide.* College Art Association, New York.

15. ———. (1979). *Ceramic Health Hazards,* Hazards in the Arts, Chicago, IL.

16. ———. (1980). Glassblowing hazards. *Glass Studio* #11, 34.

17. ———. (1980). Hazards of stained glass. *Glass Studio* #10, 33.

18. Baxter, P. J., Samuel, A. M., and Holkham, M.P.E. (1985). Lead hazards in British stained glass workers. *Br. J. Ind. Med.* 291, 6492.

19. Berendosohn, R. (1987). Clearing the air. *Fine Woodworking* Nov/Dec, 70–75.

20. Bond, J. (1976). Occupational hazards of stained glass workers. *Glass Art* 4(1), 45.

21. Braun, S., and Tsiatis, A. (1979). Pulmonary abnormalities in art glassblowers. *J Occup. Med.* 21(7), 487–489.

22. Buie, S.E., Pratt, D.S., and May, J. J. (1986). Diffuse pulmonary injury following paint remover exposure. *Am. J. M. Ed.* 81(4),702–704.

23. Canadian Centre for Occupational Health and Safety. (1988). Infograms on Hand Tools. 16 pp. CCOHS, Hamilton, Ont., Canada.

24. ———. (1988). Infograms on Powered Hand Tools. 11 pp. CCOHS, Hamilton, Ont., Canada.

25. ———. (1988). Infograms on Woodworking Machines. 10 pp. CCOHS, Hamilton, Ont., Canada.

26. ———. (1988). Infograms on Welding. 17 pp. CCOHS, Hamilton, Ont., Canada.

27. Carnow, B. (1975). *Health Hazards in the Arts and Crafts.* Hazards in the Arts, Chicago, IL.

28. ———. (1976). Health hazards in the arts. *Amer. Lung Assoc. Bull.,* January /February, 2–7.

29. Center for Safety in the Arts. (1978 to 1998). *Art Hazards News.* (available at http://www.chicagoartistsresource.org/?q=section/737/751.

30. Challis, T., and Roberts, G. (1984). *Caution: A Guide to Safe Practice in the Arts and Crafts.* Sunderland Polytechnic Faculty of Art and Design, England.

31. Clark, N., Cutter, T., and McGrane, J. (1984). *Ventilation.* Lyons & Burford, Publishers, New York, NY.

32. Clement, J.D. (1976). *An Assessment of Chemical and Physical Hazards in Commercial Photographic Processing.* M.S. thesis, University of Cincinnati, Cincinnati, OH.

33. Crenshaw, M. (1985). Hazards of processing chemistry. In *International Symposium on Holography Conference Notes*. Lake Forest College, Lake Forest, IL.

34. Curry, S., Gerkin, P., Vance, M., and Kimkel, D. (1987). Ingestion of lead-based ceramic glazes in nursing home residents. Presented at annual meeting American Assoc. of Poison Control Centers, Vancouver, BC, Canada.

35. Department of National Health and Welfare, Canada. (1988). The Safer Arts: the Health Hazards of Arts and Crafts Materials. (10 Posters) Department of Supply and Services Catalogue Number H422/10-1988E, Ottawa, Ont., Canada.

36. Dreggson, A. (1977). Lead poisoning. *Glass* 5(2), 13.

37. Driscoll, R.J., Mulligan, W.J., Schultz, D., and Candelaria, A. (1988). Malignant mesothelioma: a cluster in a native American population. *New Engl. J. Med.* 318,1437–1438.

38. Duvall, K. and Hinkamp, D. (2001). *Health Hazards in the Arts. Occupational Medicine: State of the Art Reviews.* Hanley & Belfus, Philadelphia, PA.

39. Eastman Kodak Co. (1977). *Safe Handling of Photographic Chemicals.* Eastman Kodak, Rochester, NY.

40. ———. (1987). General guidelines for ventilating photographic processing areas, CIS-58. Eastman Kodak, Rochester, NY.

41. Feldman, R., and Sedman, T. (1975). Hobbyists working with lead. *New Engl. J. Med.* 292,929.

42. Fink; T. J. (1990). Chemical hazards of woodworking. *Fine Woodworking.* Jan/Feb, 58–63.

43. Firenze, R. B., and Walters, J.B. (1981). *Safety and Health for Industrial/ Vocational Education for Supervisors and Instructors.* National Institute for Occupational Safety and Health/Occupational Safety and Health Administration, Washington, DC. (out of print)

44. Fischbein, A., Wallace, J., Sassa, S., Kappas, A., Butts, G., Rohl, A., Kaul, B. (1992). Lead poisoning from large restoration and pottery work: unusual exposure source and household risk. *Journal of Environmental Pathology, Toxicology and Oncology.* 11 (1), 7–11.

45. Food and Drug Administration. (1991). Getting the lead out. *FDA Consumer* July–August, 1991, 26–31.

46. Foote, R. (1977). Health hazards to commercial artists. *Job Safety and Health* November, 7.

47. Freeman, V., and Humble, C.G. (1989). Prevalence of illness and chemical exposures in professional photographers. Presented at the 1989 Annual Meeting of the American Public Health Association, Boston, MA.
48. Fuortes, L. J. (1989). Held hazards of working with ceramics. Recommendations for reducing risks. *Postgraduate Medicine.* 85 (1), 133–136.
49. Goh, C. (1988). Occupational dermatitis from gold plating. Contact *Dermatitis.* 18 (2), 122–123.
50. Graham, J., Maxton, D., and Twort, C. (1981). Painter's palsy: a difficult case of lead poisoning. *Lancet* November 21, 1159.
51. Hall, A.H., and Rumack, B.H. (1990). Methylene chloride exposure in furniture stripping shops: ventilation and respirator use practices. *J. Occup. Med.* 32(1), 33–37.
52. Halpern, F., and McCann, M. (1976). Health hazards report: caution with dyes. *Craft Horizons.* August, 46–49.
53. Handley, M. (1988). *Photography and Your Health.* Hazard Evaluation System and Information Service, California Department of Health Services, Berkeley, CA.
54. Hedeboe, J., Moller, L. F., Lucht, U., and Christensen, S.T. (1982). Heat generation in plaster-of-paris and resulting hand burns. *Burns* 9(1), 46–48.
55. Helper, E., Napier, N., Hillman, M., and Gatz, R. (1979). *Final Report on Product/Industry Profile on Art Materials and Selected Craft Materials* (3 parts). Battelle, Columbus, OH.
56. Henderson, R., and K. Schulmeister. (2003). *Laser Safety.* Institute of Physics Publishing, Bristol.
57. Hodgson, M., and Parkinson, D. (1986). Respiratory disease in a photographer. *Am. J. Ind. Med.* (4), 349-354.
58. Houk, C., and Hart, C. (1987). Hazards in a photography lab; a cyanide incident case study. *J. Chem. Educ.* 64 (10), A234–A236.
59. Hughes, R., and Rowe, M, (1982). *The Coloring, Bronzing, and Patination of Metals.* Craftscouncil, London, England.
60. Jenkins, C. L. (1978). Textile dyes are potential hazards. *J. Environ. Health* 40(5), 279-284.
61. Johnson, L. M., and Stinnett, H. (1991). *Water-Based Inks: A Screenprinting Manual for Studio and Classroom.* 2nd ed. Philadelphia Colleges of the Arts Printing Workshop, Philadelphia, PA.
62. Kern, D.G., and Frumkin. H. (1988). Asbestos-related disease in the jewelry industry: Report of two cases. *Amer. J. Ind. Med.* 13, 407–410.

63. Kipen, H., and Lerman, Y. (1986). Respiratory abnormalities among photographic developers: a report of three cases. *Am. J. Ind. Med.* 9(4), 341–347.

64. Lead Industries Association. (1972). *Facts About Lead Glazes for Artists, Potters and Hobbyists.* Lead Industries Assoc., New York, NY.

65. Letts, N. (1991). Artist dies in basement cyanide accident. *Art Hazards News* 14(1), 1.

66. Liden, C. (1984). Occupational dermatoses in a film laboratory. *Contact Dermatitis* 10(2), 77–87.

67. Lu, P. C. (1992). A health hazard assessment in school arts and crafts. *Journal of Environmental Pathology, Toxicology and Oncology.* 11 (1), 12–17.

68. Lucas, A. D., Salisbury, S. A. (1992). Industrial hygiene survey in a university art department. *Journal of Environmental Pathology, Toxicology and Oncology.* 11 (1), 21–27.

69. Lydahl, E., and Pjhilipson, B. (1984). Infrared radiation and cataract. II. Epidemiological investigation of glass workers. *Acta Ophthalmol.* 62(6), 976–992.

70. Mallary, R. (1983). The air of art is poisoned. *Art News* October, 34.

71. McCann, M. (1974–78). Art hazards news column. *Art Workers News.* New York, NY.

72. ———. (1975). Health hazards in printmaking. *Print Review* 34,20.

73. ———. (1976). Health hazards in painting. *American Artist* February, 73.

74. ———. (1978). The impact of hazards in art on female workers. *Preventive Medicine* 7, 338–348.

75. ———. (1992). Occupational and environmental hazards in art. *Env. Res.* 59, 139–144.

76. ———. (2005). *Artist Beware.* 3rd ed., The Lyons Press, Guilford, CT.

77. ———. (1992). Emergency response to spills and leaks. Center for Safety in the Arts, New York, NY.

78. ———. (1996). Hazards in cottage industries in developing countries. *American Journal of Industrial Medicine.* 30 (2), 125.

79. ———. (1998). *Art Safety Procedures: A Health and Safety Manual for Art Schools and Art Departments.* 2nd ed. Center for Safety in the Arts, New York, NY. Available at: http://www.uic.edu/sph/glakes/harts/index.htm

80. ———. (1998). Occupational hazards in the arts, in *Environmental and Occupational Medicine.* 3rd ed., Little, Brown and Company, Boston, MA.

81. McCann, M., and Barazani, G. (Eds.) (1980). *Health Hazards in the Arts and Crafts: Proceedings of the SOEH Conference on Health Hazards in the Arts and Crafts.* Society for Occupational and Environmental Health, Washington, DC.

82. McGrane, J. (1986). *Reproductive Hazards in the Arts and Crafts.* Center for Safety in the Arts, New York, NY.

83. Miller, A.B., and Blair, A. (1983). Mortality patterns among press photographers (letter). *J Occup. Med.* 25, 439–440.

84. Miller, AB., Blair, A., and McCann, M. (1985). Mortality patterns among professional artists: A preliminary report. *J Environ. Path.Toxicol. Oncol.* 6, 303–313.

85. Miller, A.B., Silverman, D. T., Hoover, R.N., and Blair, A. (1986). Cancer risk among artistic painters. *Am. J. Ind. Med.* 9, 281–287.

86. Miller, S.C. (1997). *Neon Techniques.* 4th ed. Cincinnati, OH: ST Publications.

87. MMWR. (1982). Chromium sensitization in an artist's workshop. *Mortality and Morbidity Weekly Reports* 31, 111.

88. Moses, C., Purdham, J., Bowhay, D., and Hoslin, R. (1978). *Health and Safety in Printmaking.* Occupational Hygiene Branch, Alberta Labor, Edmonton, Alberta, Canada.

89. Murgia, N., Muzi, G., dell'Omo, M., et al. (2007). An old threat in a new setting: High prevalence of silicosis among jewelry workers. *Amer. J. Ind. Med.* 50: 577-583.

90. National Institute for Occupational Safety and Health. (1983). *Preventing Health Hazards from Exposure to Benzidine-Congener Dyes.* DHHS (NIOSH) Publication #83-105. NIOSH, Cincinnati, OH.

91. Nelson, L.S., Shih, R.D., Balick, M.J.(2007). *Handbook of Poisonous and Injurious Plants.* 2nd ed. New York Botanical Garden, New York.

92. Ng, T.P., Allen, W.G.L., Tsin, T.W., and O'Kelly, F.J. (1985). Silicosis in jade workers. *Amer. Rev. Resp. Dis.* 42(11), 761–764.

93. Nixon, W. (1980). Safe handling of frosting and etching solutions. *Stained Glass* Fall, 215.

94. Odia, S. G., Rakoski, J., Puerschel, W. C., Ring, J. (1996). Trichloroethylene and concomitant contact dermatitis in an art painter. *Contact dermatitis.* 34 (6), 430–431.

95. Office of Compliance, Center for Devices and Radiological Health. (1986). Laser Light Show Safety. Who's Responsible. HHS Publication FDA 86-8262. Rockville, MD: Food and Drug Administration.

96. Office of Environmental Health Hazard Assessment. (2003). Guidelines for the Safe Use of Art and Craft Materials. California Environmental Protection Agency; Sacramento, CA. Available at http://www.oehha.ca.gov/education/pdf_zip/GUIDE805.pdf.

97. Ontario Crafts Council. (1980). *Crafts and Hazards to Health* (bibliography). Ontario Crafts Council, Toronto, Canada.

98. Ontario Lung Association. (1982). *Health Hazards in Arts and Crafts.* American Lung Association, New York, NY.

99. Edward Orton Jr. Ceramic Foundation. (1990). *Kiln Safety.* Edward Orton Jr. Ceramic Foundation, Westerville, OH.

100. Ouimet, T. (2000). Safety Guide for Art Studios. United Educators Insurance. Available at: http://intranet.risd.edu/pdfs/UEArtSafety-BookFinalPg1to9.pdf

101. Potato, R., Morossi, G., Furlan, I., and Moro, G. (1989). Risk of abnormal lead absorption in glass decoration workers. *Med. Lav.* 80(2),136–139.

102. Prockup, L. (1978). Neuropathy in an artist. *Hospital Practice* November, 89.

103. Pyle, D. (2007). The top questions on health and Safety. The Artist's Magazine. May, 2007. Available at: http://www.artistsmagazine.com/blog/Free+Art+Materials+Health+And+Safety+Guide.aspx

104. Quinn, M., Smith, S., Stock, L., and Young, J. (Eds.) (1980). *What You Should Know About Health and Safety in the Jewelry Industry.* Jewelry Workers Health and Safety Research Group, Providence, RI.

105. Radaydeh, B.N. and Otoom, S.A. (2004). Testing the awareness of hazardous nature of printmaking materials among printmaking students in traditional and non-toxic printmaking programs. *Journal of Health Science* 50(6):570-575.

106. Ramazzini, B. (1940). *De Morbis Artificum (Diseases of Workers).* 2nd ed. (1713). Translated by W. C. Wright, University of Chicago Press, Chicago, IL.

107. Reed, L. D. (1986). Health Hazard Evaluation Report No. HETA-82-059-1752, Art Academy of Cincinnati, Cincinnati OH. National Institute for Occupational Safety and Health, Cincinnati, OH.

108. Rempel, S. and Rempel, W. (1992). *Health Hazards Manual for Photographers.* The Lyons Press, New York, NY.

109. Rickard, T., and Angus, R. (1983). *A Personal Risk Assessment for Craftsmen and Artists.* Ontario Crafts Council/College, University and School Safety Council of Ontario, Toronto, Canada.

110. Rossol, M. (1980–82). Ceramics and Health. Compilation of articles from *Ceramic Scope.*

111. ———. (1991). *Professional Stained Glass Safety Training Manual: Our Right-To-Know Program.* The Edge Publishing Group, Inc., Brewster, MA.

112. ———. (1992). The first art hazards course. *Journal of Environmental Pathology, Toxicology and Oncology.* 11 (1), 28.

113. ———. (2002). *The Artist's Complete Health and Safety Guide.* 3rd ed. Allworth Press, New York, NY.

114. Seeger, N. (1984). Alternatives for the Artist. Revised editions, School of the Art Institute of Chicago, Chicago, IL.

115. ———. *An Introductory Guide to the Safe Use of Materials.*

116. ———. *A Printmaker's Guide to the Safe Use of Materials.*

117. ———. *A Photographer's Guide to the Safe Use of Materials.*

118. ———. *A Painter's Guide to the Safe Use of Materials.*

119. ———. *A Ceramist's Guide to the Safe Use of Materials.*

120. Semenoff, Nik. "Waterless Lithography Using Tradional Grained or Commercial Photosensitive Plates." *Leonardo* 26(4): 303-308, 1993.

121. ———. "Waterless Lithography II," *Printmaking Today* 4(Summer Issue): 26-28, 1995.

122. Semenoff, Nik and L.W. Bader. "Intaglio Etching On Aluminum And Zinc Using An Improved Mordant", *Leonardo* 31(2): 133–138. 1998.

123. Semenoff, Nik and Christine Christos. "Using Dry-Copier Toner and Electro-Etching on Intaglio Plates", *Leonardo* 24(4): 389-394, 1991.

124. Semko, Jacob. *Waterless Lithography: An Artist's Guide to Making Professional-Quality Prints using Nik Semenoff's Method.* Parker, Colorado: Outskirts Press, 2005.

125. Shaw, S. (1985). In process: reproductive hazards in photography. *Photomethods* 28(6).

126. Shaw, S., and Rossol, M. (1991). *Overexposure: Health Hazards in Photography,* 2nd ed. Allworth Press, New York, NY.

127. Shaw, S., and Rossol, M. (1989). Warning: Photography May Be Hazardous to Your Health. *ASMP Bulletin* 8(6) . entire issue.

128. Siedlicki, J. (1968). Occupational health hazards of painters and sculptors. *J. Am. Med. Assoc.* 204, 1176.

129. ———. (1972). Potential hazards of plastics used in sculpture. *Art Education* February, 78.

130. ———. (1975). *The Silent Enemy.* 2nd ed. Artists' Equity Association, Washington, DC.

131. Spandorfer, M., Snyder, J., and Curtiss, D. (1997). *Making Art Safely: Alternative Processes in Drawing, Painting, Printmaking, Graphic Design, and Photography.* Wiley, John and Sons, New York, NY.

132. Stewart, R., and Hake, C. (1976). Paint-remover hazard. *J. Am. Med. Assoc.* 235, 398.

133. Stopford, W. (1988). Safety of lead-containing hobby glazes. *North Carolina Med. J.* 49(1), 31–34.

134. Swam, G.M.H., Passier, P.E.C.A., and Van Attekum, A.M.N.G. (1988). Prevalence of silicosis in the Dutch fine-ceramic industry. *Int. Arch. Occup. Environ. Health* 60(1), 71–74.

135. Tell, J. (Ed.) (1988). *Making Darkrooms Saferooms.* National Press Photographers Association, Durham, NC.

136. Waller, J. (1980). Another aspect of health issues in ceramics. *Studio Potter* 8(2), 60.

137. Waller, Julian (ed.) (1987). Health and the Potter. *Studio Potter* entire June issue.

138. Waller, J.A., Payne, S.R., and Skelly, J.M. (1989). Injuries to carpenters. *J. Occup. Med.* 31 (8), 687–692.

139. Waller, J., and Whitehead, L. (1977–79). Health issues (regular column). *Craft Horizons.*

140. Waller, J., and Whitehead, L. (Eds.). (1977). *Health Hazards in the Arts—Proceedings of the 1977 Vermont Workshops.* University of Vermont Department of Epidemiology and Environmental Health, Burlington, VT.

141. Weiss, L. (1987). *Health Hazards in the Field of Metalsmithing.* Society of North American Goldsmiths Education and Research Department.

142. Weiss, S.J. and Lesser, J.H. (1997). Hazards associated with metalworking by artists. *South. Med. J.* 90, 665–71.

143. Wellborn, S. (1977). Health hazards in woodworking. *Fine Woodworking* Winter, 54–57.

144. Wenyon, M. (1985). *Understanding Holography.* 2nd ed. New York: Arco Publishing, Inc.

145. White, N.W., Chetty, R., Bateman, E. (1991). Silicosis among gemstone workers in South Africa. *Am. J. Ind. Med.* 19, 205–213.

146. Wills, J.H. (1982). Nasal cancer in woodworkers: A review. *J. Occup. Med.* 24(7), 526–530.

147. Woods, B., and Calnan, C.D. (1976). Toxic woods. *Br. J. Derm.* 9513, 1–97.

148. Zuskin, E., Mustajbegovic, J., Schacter, N.E., et al. (2004). Respiratory findings in art students. *Coll. Antropol.* 28((2): 717-725.

CHILDREN'S ART HAZARDS REFERENCES

1. Babin, A., Peltz, P., and Rossol, M. (1989). Children's art supplies can be toxic. Revised. Center for Safety in the Arts, New York, NY.
2. California Public Interest Research Group. (1984). Not a Pretty Picture: Art Hazards in the California Public Schools. CALPIRG, Sacramento, CA.
3. Jacobsen, L. (1984). *Children's Art Hazards.* Natural Resources Defense Council, New York, NY.
4. Kawai, M., Torimumi, H., Katagiri, Y., and Maruyama, Y. (1983). Home lead-work as a potential source of lead exposure for children. *Arch. Occ. Environ. Health* 53(1), 37–46.
5. Massachusetts Public Interest Research Group. (1983). *Poison Palettes: A Study of Toxic Art Supplies in Massachusetts Schools.* MASSPIRG, Boston, MA.
6. McCann, M. (1986). Health and safety for secondary school arts and industrial arts. Center for Safety in the Arts, New York, NY.
7. ———. (1988). Teaching art safely to the disabled. Center for Safety in the Arts, New York, NY.
8. New York Public Interest Research Group. (1982). *Children Beware— Art Supplies in the Classroom.* NYPIRG, New York, NY.
9. Office of Environmental Health Hazard Assessment. (2007). List of Art and Craft Materials that May Not be Purchased for Use in Grades K-6. California Environmental Protection Agency; Sacramento, CA. Available at http://www.oehha.ca.gov/education/pdf_zip/ArtListMay2007.pdf
10. Oregon State Public Interest Research Group. (1985). *Toxics in Art Supplies—Hazardous Hobbies.* Oregon PIRG, Portland, OR.
11. Peltz, P. (1984). Day care centers using toxic art materials. *Art Hazards News* March, 1.
12. Qualley, C. (1986). *Safety In the Art Room.* Davis Publications, Worcester, MA.
13. Schultz, L. (Ed.). (1982). *Art Safety Guidelines K–12.* National Art Education Association, Reston, VA.
14. U.S. Public Interest Research Group. (1986). *Not a Pretty Picture: Toxics in Art Supplies in Washington, DC Area Public Schools.* USPIRG, Washington, DC.
15. ———. (1987). *The Picture Looks Brighter: Improvements in Artroom Safety in Washington, DC Area Public Schools.* USPIRG, Washington, DC.

GENERAL REFERENCES

1. Accrocco, J.O. (1998). *The MSDS Pocket Dictionary.* 3rd ed. Genium Publishing Company, Schenectady, NY.
2. A. M. Best Company. *Best's Safety and Security Directory.* 2 Volumes. A.M. Best, Oldwick, NJ. (Updated regularly.)
3. American Conference of Governmental Industrial Hygienists. (2007). *Documentation of the Threshold Limit Values and Biological Exposure Indices.* 7th ed. 2007 Supplement ACGIH, Cincinnati, OH.
4. ———. (2007). *2007 TLVs and BEIs.* ACGIH, Cincinnati, OH.
5. American National Standards Institute. (2004). *American National Standard for Emergency Eyewash and Shower Equipment* ANSI Z358.1-2004. ANSI, New York, NY.
6. ———. (2007). *Fundamentals Governing the Design and Operation of Local Exhaust Systems.* ANSI Z9.2-2007. ANSI, New York, NY.
7. ———. (2003). *American National Standard Practice for Occupational and Educational Eye and Face Protection* ANSI Z87.1, 2003 edition. ANSI, New York, NY.
8. ———. (1992). *American National Standard Practices for Respiratory Protection.* ANSI Z88.2-1992. ANSI, New York, NY.
9. ———. (2005). *Safety in Welding and Cutting and Allied Processes.* ANSI Z49.1-2005. ANSI, New York, NY.
10. Committee on Industrial Ventilation. (2007). *Industrial Ventilation: A Manual of Recommended Practice for Design.* 26th ed., American Conference of Governmental Industrial Hygienists, East Lansing, MI. (Updated regularly).
11. Environmental Protection Agency. 40 CFR 260 to 267. *Hazardous Waste Management Regulations.* Government Printing Office, Washington, DC.
12. Gosselin, R., Smith, R., and Hodge, H. (1990). *Clinical Toxicology of Commercial Products.* 5th ed., Williams and Wilkins, Baltimore, MD.
13. Harris, R.L. (Ed.) (2000). *Patty's Industrial Hygiene,* 4 volumes, 5th ed., John Wiley and Sons, New York, NY.
14. Industrial Hygiene Subcommittee, Alliance of American Insurers. (1987). *Handbook of Organic Industrial Solvents.* 6th ed. Alliance of American Insurers, Chicago, IL.
15. Klaasen, C. D. (2007). *Casarett and Doull's Toxicology: The Basic Science of Poisons.* 7th ed., McGraw Hill., New York, NY.
16. Lewis, R. (1991). *Carcinogenically Active Chemicals: A Reference Guide.* Van Nostrand Reinhold, New York, NY.

17. Lewis, R. J. (2007). *Hawley's Condensed Chemical Dictionary.* 15th abridged ed. John Wiley and Sons, New York, NY.

18. ———. (2004). *Sax's Dangerous Properties of Industrial Materials.* 11th ed. John Wiley and Sons, New York, NY.

19. National Fire Protection Association. (2007). *NFPA #10.* Portable Fire Extinguishers. NFPA, Quincy, MA.

20. ———. (2000). *NFPA #30.* Flammable and Combustible Liquids Code. NFPA, Quincy, MA.

21. ———. (2000). *NFPA #45.* Standard on Fire Protection for Laboratories Using Chemicals, 2000 Edition. NFPA, Quincy, MA.

22. ———. (2001). *NFPA #58.* Liquefied Petroleum Gas Code, 2001 Edition. NFPA, Quincy, MA.

23. ———. (2007). *NFPA #70.* National Electrical Safety Code, 2007 Edition. NFPA, Quincy, MA.

24. National Institute of Occupational Safety and Health. (1987). *A Guide to Industrial Respiratory Protection.* DHEW (NIOSH) #87-116. Government Printing Office, Washington, DC.

25. National Institute for Occupational Safety and Health. *Criteria for Recommended Standards: Occupational Exposure To* [various chemicals]. Government Printing Office, Washington, D.C.

26. National Institute for Occupational Safety and Health. (1977). *Occupational Diseases: A Guide to Their Recognition,* revised ed., Government Printing Office, Washington, DC.

27. National Institute for Occupational Safety and Health. (2002). *NIOSH Certified Equipment List* DHEW (NIOSH) Available at http://www2a.cdc.gov/drds/cel/cel_form_code.asp

28. National Institute for Occupational Safety and Health. (1986). *Working in Hot Environments,* DHHS (NIOSH) Publication #86-112. NIOSH, Cincinnati, OH.

29. New Jersey Right To Know Program. NJ Hazardous Substance Fact Sheets on [various chemicals]. New Jersey State Department of Health, Trenton, NJ.

30. Occupational Safety and Health Administration. (2001). *Occupational Safety and Health Standards for General Industry.* 29 CFR 1910. Government Printing Office, Washington, DC.

31. Pinsky, M. (1987). *The VDT Book—A Computer User's Guide to Health and Safety.* New York Committee for Occupational Safety and Health, New York, NY.

32. Stellman, J. M. (Ed.). (1998). *Encyclopedia of Occupational Health and Safety.* 4 volumes. 4th ed. International Labor Office, Geneva, Switzerland.
33. Stellman, J. and Daum, S. (1973). *Work Is Dangerous to Your Health.* Vintage, New York, NY.
34. U.S. Congress, Office of Technology Assessment. (1985). *Reproductive Health Hazards in the Workplace.* OTA-BA-266. U.S. Government Printing Office, Washington, DC.

INDEX

Page numbers followed by t indicate tables.
Page numbers in boldface refer to illustrations.